// Webworks

e-commerce

GLOUCESTER MASSACHUSETTS

ROCKPORT PUBLISHERS

Katherine Tasheff Carlton

First published in the United States of America by
Rockport Publishers, Inc.
33 Commercial Street
Gloucester, Massachusetts 01930-5089
Telephone: (978) 282-9590
Facsimile: (978) 283-2742
www.rockpub.com

ISBN 1-56496-661-5

10 9 8 7 6 5 4 3 2 1

Design: Otherwise Inc.
Front cover images (from left to right): Hallmark
World Flower Market, p. 22; Electronic Arts, p. 150;
Harrods, p. 49
Back cover images (from left to right): World Flower
Market, p. 25; Datek Online, p. 108; ¡Want.com, p.
174
ImageCafé: Reprinted with Express permission.
Copyright 2000 Network Solutions, Inc. All rights
reserved.

Wall Street Jornal: Reproduced with permission
from Dow Jones & Company, Inc. Copyright 2000
by Dow Jones & Company, Inc.

The Motley Fool: Copyright 1996-2000 The Motley
Fool. All rights reserved.

EBSCO: Copyright 2000 EBSCO Publishing.

Printed in China.

// Webworks
e-commerce

ROCKPORT

Acknowledgments

Without the support and input of individuals from each website profiled in this book, this project would not have happened. In particular, some people went above and beyond the call of duty to research, answer questions, provide information, and shepherd me through the corporate hierarchy.

Special thanks to:
Sean Wechter, without whom I wouldn't have been able to get this project off the ground.
Whitney Vliet, who helped me find the right people and provided important feedback throughout this effort.

Thanks also to Steve Bellis at *Hallmark*, Iain Jones at *Harrods*, Denise Trabona at *Drugstore.com*, Shasha Richardson at *Nordstrom*, Ashley Matchett at *bSource*, Dan Gilmartin at *ImageCafe*, Geoff Malta and Gregg Sanderson at *Marvel*, Margaret McCann at *Bluefly.com*, Rhonda Wells at *Payless Shoes*, Jennifer Edson at *The Wall Street Journal*, Bryant Hilton at *Dell.com*, Earl de Wijs and Gijs Garcia Bogaards at *netdesign.nl*, Charlie Bowman at *Philips Lighting*, Mike Bucco at *EBSCO* publishing, and Damon Myers and Bill O'Neil at *xalient.com*. An extra thanks and set of angel's wings to Lenny Lapenta at *xalient.com* for all of his hard work, dedication, and attention to detail.

My gratitude to the team at Rockport Publishers for helping me navigate the publishing process, especially Winnie Prentiss, for giving this book a chance, Jonathan Ambar, for helping me shape the idea into something understandable, Jay Donahue for not losing his mind when clearly he had the right to, Kristy Mulkern for smart, quick, and professional answers to all kinds of questions, and most importantly to Ann Fox for her unwavering understanding, expert advice, and wisdom. Everyone should have a project manager like her.

On a more personal note, I'd like to thank my husband Ken, and my son, Benjamin, for their love and patience through this process, my parents for their constant support, and my friend Brooke Fleming for making this all happen in the first place.

Contents

5 Acknowledgments

8 Introduction

12 Chapter 1: Consumer and Retail Sites

14 chipshot.com

22 hallmarkflowers.com

28 Nordstrom.com

36 drugstore.com

42 MuZicDepot.com

46 harrods.com

52 wine.com

58 payless.com

64 StarMedia.net/shopping

68 bluefly.com

74 Chapter 2: Finance, Banking, and Business-to-Business Sites

76 fool.com

82 NextCard.com

88 ImageCafe.com

94 WingspanBank.com

100 citbank.com.hk

104 PayPal.com

108 **Datek.com**

112 Chapter 3: **Intranet and Extranet Sites**

114 **EdFinder.com**

118 **wsj.com**

124 **tradelink.philips.com**

128 **forrester.com**

134 **bng.com**

138 **dell.com**

146 **EBSCO.com/research**

150 **ea.com**

156 Chapter 4: **Other e-commerce Concepts**

158 **marvel.com**

164 **bSource.com**

172 **PCGamer.com**

178 **iWant.com**

182 **ab2000.nl**

186 **Directory**

188 **About the Author**

Introduction

by Katherine Tasheff Carlton

The customer is king. The rule my great-grandfather upheld while operating a corner grocery store in the early 1900s still applies in the world of electronic commerce. Customers want to have their needs met as quickly and conveniently as possible. With an estimated 304 million people online worldwide and the average duration of a page view less than one minute, e-commerce customers are increasingly interested in the expedience the technology offers, not the technology itself. Most of the novelty of online transactions has worn off; people want to get online, make their purchases, and get on with other activities. Sites must immediately grab attention. If users are not intrigued or satisfied, they move on—quickly.

Repeatedly, the conversations I've had with site designers have boiled down to this: Simplicity is the key to e-commerce design. As most developers know, a design that appears simple is often the most complicated to create. With nearly one out of every three Internet users making online purchases, e-commerce site developers must tread a delicate line between utility and aesthetics. Beyond the retail-oriented sites, the corporate world has almost universally made the leap to online transactions. Pull-down menus, heavy back-end databases, secure servers, limited bandwidth, and brand marketing all must be taken into account while creating a visually pleasing, easy-to-use environment.

What does simplicity in design really mean? More often than not, ease of use is the bottom line. This means that the most important aspect of e-commerce design is understanding the company's business model and knowing how customers will access the site and what they will demand when they do.

Many designers try to do too much, loading sites with too many bells and whistles or presenting so much information on the home page that users are immediately lost. Occasionally, the original model was a good starting point, but through the rapid expansion possible in the interactive age, sites outgrow their systems, navigation, and basic design.

Sometimes simplicity in design means not changing the site around to accommodate every new advance in technology. As Rhonda Wells, director of e-commerce for Payless ShoeSource, says, "How do you feel in this scenario? You're in the middle of cooking dinner for guests that evening when you realize you're out of an ingredient. Time is of the essence, so you drive to the grocery store you frequent once a week and double-park knowing you'll only be five minutes maximum. Once inside, you run to the middle of the aisle on the left-hand side where the ingredient is always stocked, but it's not there—in fact, nothing that belongs there is there. The store has changed and you're not happy—you're frustrated. Then you're even more frustrated when the store manager explains that the change was made to enhance your shopping experience." Customers must be able to appreciate the improvement in the site; otherwise, you may lose their business.

No hard-and-fast rules exist on the Internet; things change too quickly for rules. But over the past few months, I've been able to identify guidelines that every e-commerce designer should take into consideration:

- Know what technology you need to deliver what your customers want. If you're fulfilling customers' orders via e-mail, you don't need a comprehensive e-commerce environment. But if you have 20,000 items in inventory, spend the time to develop a system and interface that really work. Skimping will mean slow site operation and customers who can't find what they're looking for.
- Do the research. The coolest Flash introduction in the world is a complete waste of time, energy, and money if most of your customers are connecting through their local libraries or around the world at significantly slower rates than here in the States. Even high-speed customers may not want to wait.
- Balance navigation and information carefully. This is a tough one. People want their information as quickly as possible, but too much content at once leaves the customer feeling confused and stranded. Even FAO Schwarz doesn't display all their merchandise at one time.
- Don't try to do too much. When we work with this technology all day long, there's a tendency, almost a driving need, to utilize new technologies to make a site more interesting. Unfortunately, most customers aren't impressed and often are actually turned off. The technology should be transparent; the user experience should be seamless.

Electronic commerce is more than buying widgets online. In fact, some people define e-commerce broadly enough to include the use of fax machines to place orders. For the purposes of this publication, I've defined electronic commerce as the use of the Internet for initiating, conducting, or fulfilling the requirements of a business transaction. I've tried to cover an extremely broad range of e-commerce businesses, from the big online retailers like drugstore.com and Nordstrom to electronic marketplaces like bSource and subscription sites like *The Wall Street Journal.* By the time this book is published, I'm sure many new technologies will enable still more types of e-commerce sites. But in the spectrum of enterprises included here, I hope that designers and entrepreneurs will find design approaches, innovative uses of technology, and navigational concepts that will help them in building their own sites.

Consumer and Retail Sites

>> **Consumer and Retail Sites**

>> **Finance, Banking, and Business-to-Business Sites**

Most people would be hard-pressed to think of a single product or service that can't be purchased on the web: flowers, clothes, music, prescriptions, shoes, groceries, office supplies, and even cars can be ordered online and delivered to your door. New consumer-oriented dot.coms appear on the web every day, flooding the marketplace with product offerings. The most successful online retailers have one thing in common: They make it fun and easy to find the right merchandise and even easier to purchase. Some people complain that the shipping charges levied by the online merchants negate the value of shopping online. As long as customers can access a website, find the perfect gift for their sister's new baby, and have it wrapped and delivered overnight, they're going to be willing to pay a little extra for the service.

As Sean Wechter, director of electronic commerce development for chipshot.com, says, "The basics of e-commerce involve making the site clean, with as slippery a slope as possible to the checkout." Making it easy for customers to find the product they want and speeding them along to entering their credit card number means a successful site. If customers had trouble finding the potato chips at a convenience store and then had to stand in line for 15 minutes to purchase them, they wouldn't be back. Where's the convenience? The whole concept behind shopping online is the same.

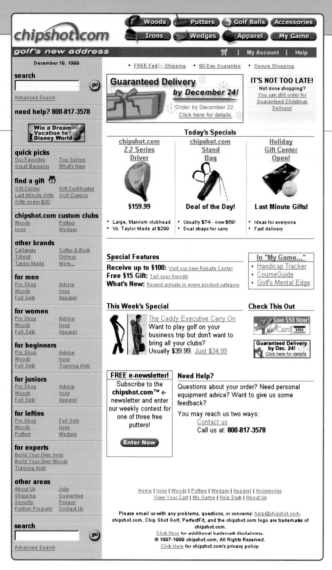

>> The chipshot.com home page allows users to search, find the category they're most interested in, or jump right into one of the featured specials.

Golf's New Address

- Don't make the customer wait for anything.
- Minimize the number of clicks to the checkout.
- Customers want all the information in one place.

01
chipshot.com

About the Site

Chipshot.com caters to the notoriously conservative golfing crowd—not what you might expect from a hot Silicon Valley operation. So how do they merge cutting-edge high tech with a conservative, college-educated, affluent, mostly male clientele? Understand the audience. Focus on the product. Make the site clean, with as slippery a slope as possible to the checkout.

About the Customer

Some people who come to the chipshot.com website know exactly what they want; some don't. Some are Internet experts; some are novices. "The site must create as wide a net as possible to catch all the potential customers," says Tom Loretan, VP of production and design. "As a result, there's no point in using the kinds of features and technology that will eat up bandwidth. Each second someone waits means increasing the possibility that they won't make a purchase."

Site Design

Every product on chipshot.com has an accompanying detailed photo. For the chipshot.com clubs, customers can see three-dimensional rotating views of the head and close-ups of the shaft and grip. All of the images provide a sense of the texture and metals used in the products. There's also some editorial copy comparing similar products to further educate the shopper.

White and shades of green throughout the site not only contribute to the clean feeling but also help ad banners and specials pop out. Especially user-friendly features include a complete navigation bar at the top of every screen, so the customer can jump to another section at any time, and a printable gift certificate for those inevitable last-minute gifts.

"E-commerce is a constantly moving target," says Sean Wechter, director of e-commerce development for chipshot.com. "Once we get the style down, we have to stay with it to preserve the brand. If our customers can't identify our site, we're lost. E-commerce is our only source of revenue.

chipshot.com: 1452 Kifer Road, Sunnyvale, CA 94086, (408) 746-0600

Executives: Sean Wechter, Director of E-Commerce Development; Tom Loretan, Vice President of Production and Design **Design Team:** Jan Kennedy, Managing Graphic Designer; Caryn Fukui, Web Team Manager **Toolbox:** HTML (no JavaScript at this point), High-quality digital camera (with experienced photographer), Animated gifs

16 17 18 19 20 21 22 23 24 25 26 27 28 29 30

Understand the audience. Focus on the product. Make the site clean, with as slippery a slope as possible to the checkout.

>> The standard navigation bar lets users jump within the site at anytime. It also provides a style frame for all pages.

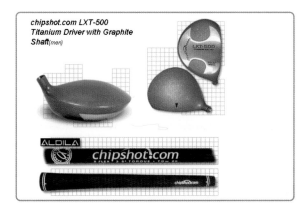

>> Close-ups of the product give customers an accurate sense of texture for each club.

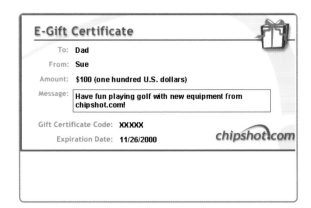

>> The consistent use of green and white throughout the site makes featured specials, like this one, using red, stand out on the page.

- **Website Objective:** The chipshot.com site is designed to help consumers easily find all the golf-related products they need in a simple-to-navigate site, or through informative expert advice. The personal needs of each consumer are addressed through custom-created golf products crafted specifically for each individual.

- **Creative Strategy:** Easy to use, informative, appropriate. E-commerce leader whose design will become an industry standard.

- **Target Audience:** A conservative, college-educated, affluent, mostly male clientele.

1. chipshot.com LXT-500 Titanium Driver with Graphite Shaft

The two most important features for increasing your chances of success off the tee are an oversize clubhead and large clubface. These were our main goals in designing the attractive, tumble-grey LXT-500 driver.

Price: $159.99

>> Prices and buy buttons are featured on the first product page.

Guaranteed Delivery by December 24!
Order by December 22.
Click here for details.

>> Printable gift certificates are a popular new addition to the site—no waiting for them to arrive in the mail.

17

My Game

Men | **Women**

Welcome! This is where you'll find advice and features to improve and inspire your game.

Tip of the Week

Stabilize Your Left Knee

by Grant Barnes, Chipshot.com's PGA Pro

Longer hitters have a significant discrepancy between hip turn and shoulder turn. The place for a big hip turn is on the follow-through, not the backswing! One important body part that affects what the hips do is the left knee. When it collapses or bends inward, the hips are...

[Discuss this tip.]　　　　　　　　　　[More...]

>> Tips from golf pros add value and help generate repeat visitors to the site.

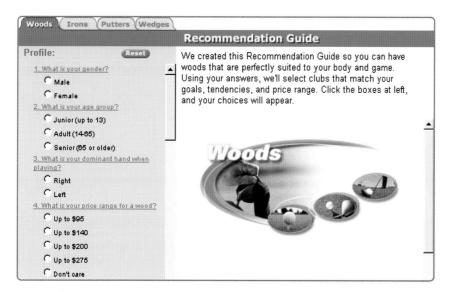

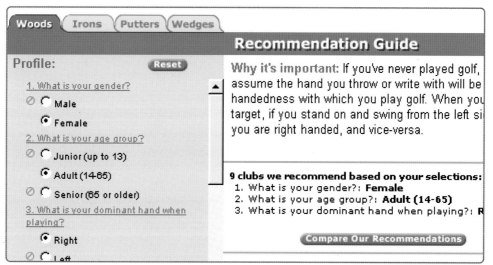

>> A comprehensive recommendation guide helps customers choose the right equipment.

Each second someone waits means increasing the possibility that they won't make a purchase.

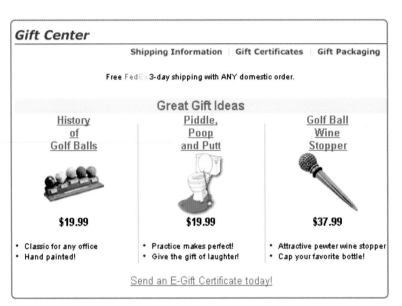

Gift Center

Shipping Information | Gift Certificates | Gift Packaging

Free FedEx 3-day shipping with ANY domestic order.

Great Gift Ideas

History of Golf Balls

$19.99

- Classic for any office
- Hand painted!

Piddle, Poop and Putt

$19.99

- Practice makes perfect!
- Give the gift of laughter!

Golf Ball Wine Stopper

$37.99

- Attractive pewter wine stopper
- Cap your favorite bottle!

Send an E-Gift Certificate today!

>> A gift center suggests gift ideas for hard-core golf fans.

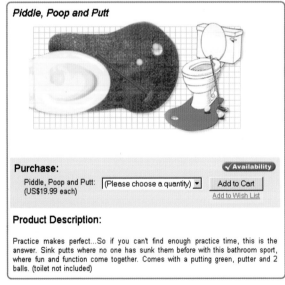

Piddle, Poop and Putt

Purchase: ✓ Availability

Piddle, Poop and Putt: (Please choose a quantity) ▼ [Add to Cart]
(US$19.99 each) Add to Wish List

Product Description:

Practice makes perfect...So if you can't find enough practice time, this is the answer. Sink putts where no one has sunk them before with this bathroom sport, where fun and function come together. Comes with a putting green, putter and 2 balls. (toilet not included)

>> All products feature helpful images and copy.

>> Real-time product availability can be accessed at the click of a button.

Advanced Search

Free FedEx 3-day shipping with ANY domestic order.

Please select any of your search criteria:

Keyword(s): []

Product type? [All ▼]

Brand Name?

☑ All ☐ Liquidmetal ☐ Precept
☐ Adams ☐ LPGA ☐ Purespin
☐ Armour ☐ Maxfli ☐ RainSwetter
☐ Callaway ☐ Mizuno ☐ Spalding
☐ Chipshot.com ☐ Nike ☐ Sun Mountain
☐ Cleveland ☐ Odyssey ☐ Taylor Made
☐ Cobra ☐ Orlimar ☐ Teardrop
☐ Cutter & Buck ☐ Ping ☐ Tehama
☐ Kevin Burns ☐ Pinnacle ☐ Titleist

Gender? [All ▼]

Age? [All ▼]

Skill? [All ▼]

Handedness? [All ▼]

Price? [All ▼]

[Search] [Clear Entries]

>> A comprehensive search engine enables users to locate just the right products.

>> Users can select different products based on the type of player for whom they are shopping.

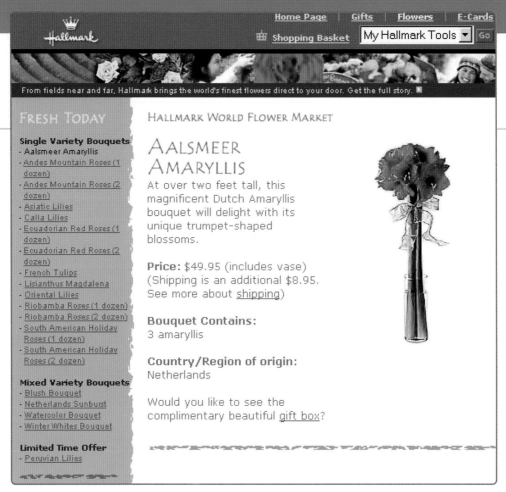

Home Page | Gifts | Flowers | E-Cards

Hallmark

⊞ **Shopping Basket** | My Hallmark Tools ▾ | Go

From fields near and far, Hallmark brings the world's finest flowers direct to your door. Get the full story. ■

FRESH TODAY

Single Variety Bouquets
- Aalsmeer Amaryllis
- Andes Mountain Roses (1 dozen)
- Andes Mountain Roses (2 dozen)
- Asiatic Lilies
- Calla Lilies
- Ecuadorian Red Roses (1 dozen)
- Ecuadorian Red Roses (2 dozen)
- French Tulips
- Lisianthus Magdalena
- Oriental Lilies
- Riobamba Roses (1 dozen)
- Riobamba Roses (2 dozen)
- South American Holiday Roses (1 dozen)
- South American Holiday Roses (2 dozen)

Mixed Variety Bouquets
- Blush Bouquet
- Netherlands Sunburst
- Watercolor Bouquet
- Winter Whites Bouquet

Limited Time Offer
- Peruvian Lilies

HALLMARK WORLD FLOWER MARKET

AALSMEER AMARYLLIS

At over two feet tall, this magnificent Dutch Amaryllis bouquet will delight with its unique trumpet-shaped blossoms.

Price: $49.95 (includes vase)
(Shipping is an additional $8.95. See more about shipping)

Bouquet Contains:
3 amaryllis

Country/Region of origin:
Netherlands

Would you like to see the complimentary beautiful gift box?

>> A focus on the flowers and minimal supporting copy guide the customer through the buying process.

Fresh Flowers from the World's Best Growers. When You Care Enough to Send the Very Best.

- Too much technology takes away from the shopping experience—keep the focus on the product.
- Don't skimp on the details; they make decision making easier for the consumer.
- Focus on clean product images. Customers want to see what they're paying for.

02
Hallmark World Flower Market

About the Website

Most e-commerce websites require intensive maintenance. The Hallmark World Flower Market website requires the kind of effort and programming that makes the mind spin. The site represents a mammoth business model that controls flowers from the grower to the customer. It's updated about every 30 days for general information, out-of-stock information is updated hourly, and real-time page updates reflect minute-by-minute inventory changes. In addition, the entire site is redesigned six to eight times a year when the model line changes.

All the work that goes on behind the scenes is practically invisible to the user. The flowers are the sole focus of the site. With a vertical list of the available flowers and bouquets in a left-hand navigation bar, previewing the options is effortless. Clear images of the flowers on a white background make it easy to choose the right bouquet. From there, simple instructions and forms and oodles of details make the site a shopper's dream. Images of the actual gift box and the enclosed card make the final order screen a complete snapshot of your shopping experience: a picture of the flowers, a review of the message on the card, and easy-to-navigate buttons to accommodate changes.

Designing and Planning

According to Steve Bellis of Hallmark, "The most important decision we made in designing the website was determining how much bandwidth we wanted to utilize for the transaction. In the end, we voted to limit environmental enhancements that eat up bandwidth. So, there's no sound, no visual high-tech goodies that can make the customer impatient. No plug-ins necessary. We invested a lot of time and effort in creating a smooth interface and a friendly shopping experience."

Branding and Identity

Bellis also notes that one of the biggest constraints in designing the site was making sure the flower website looks like a part of the Hallmark family of sites. Earthy fonts and colors set the Hallmark World Flower Market site apart from other Hallmark areas while maintaining the corporate image through banners and links. In addition, one shopping basket is linked to all areas of the Hallmark site, allowing the user to purchase gifts, cards, and flowers all at once instead of with separate transactions.

Hallmark Cards: 2501 McGee, MD 100, Kansas City, MO 64108, (800) Hallmark

Executives: Steve Bellis, General Manager, Flowers, John Sullivan, Senior Vice President for Internet Commerce
Design Team: Mary Gentry, Creative Manager

16 17 18 19 20 21 22 23 24 25 26 27 28 29 30

- **Website Objective:** Become the place on the Internet where people can find help in managing their relationships.
- **Creative Strategy:** The most important goals are a smooth interface and a friendly shopping experience.
- **Target Audience:** Broad. Men and women who are familiar with the Hallmark brand and like to use the Internet as a tool in their daily relationship management duties.

>> A uniform navigation bar at the top of every page helps maintain the corporate image, while the photomontage below tells the story of the business model: Hallmark provides the freshest flowers, straight from the grower.

>> The left-hand navigation bar lists all the options within one screen.

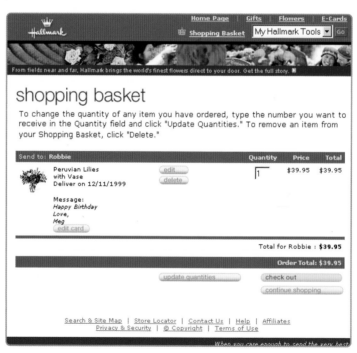

>> A complete summary of the purchase appears before the final checkout: a picture of the bouquet, the enclosed message, and the quantity, price, and total purchase amount. If changes are necessary, clear Edit and Delete buttons make it easy.

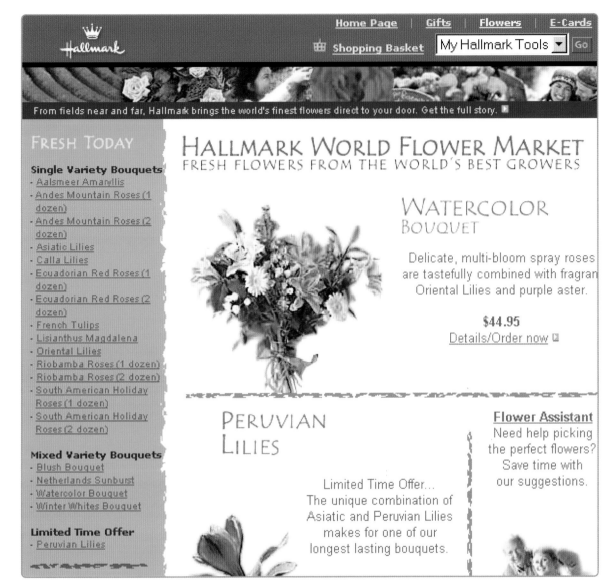

Hallmark

☐ Shopping Basket

My Hallmark Tools ▼ | Go

From fields near and far, Hallmark brings the world's finest flowers direct to your door. Get the full story. ▶

FRESH TODAY

Single Variety Bouquets
- Aalsmeer Amaryllis
- Andes Mountain Roses (1 dozen)
- Andes Mountain Roses (2 dozen)
- Asiatic Lilies
- Calla Lilies
- Ecuadorian Red Roses (1 dozen)
- Ecuadorian Red Roses (2 dozen)
- French Tulips
- Lisianthus Magdalena
- Oriental Lilies
- Riobamba Roses (1 dozen)
- Riobamba Roses (2 dozen)
- South American Holiday Roses (1 dozen)
- South American Holiday Roses (2 dozen)

Mixed Variety Bouquets
- Blush Bouquet
- Netherlands Sunburst
- Watercolor Bouquet
- Winter Whites Bouquet

Limited Time Offer
- Peruvian Lilies

HALLMARK WORLD FLOWER MARKET
FRESH FLOWERS FROM THE WORLD'S BEST GROWERS

WATERCOLOR
BOUQUET

Delicate, multi-bloom spray roses are tastefully combined with fragran Oriental Lilies and purple aster.

$44.95
Details/Order now ▣

PERUVIAN LILIES

Limited Time Offer...
The unique combination of Asiatic and Peruvian Lilies makes for one of our longest lasting bouquets.

Flower Assistant
Need help picking the perfect flowers? Save time with our suggestions.

>> The Hallmark World Flower Market home page presents all the options up front and provides assistance if the customer wants it.

Straightforward instructions and forms and oodles of details

make the site a shopper's dream.

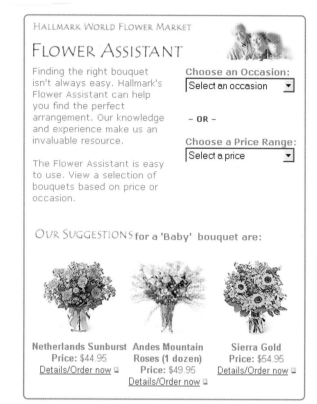

>> A Flower Assistant search engine helps find the right bouquet
for any occasion.

>> The store locator functions across all Hallmark sites.

ABOUT OUR FLOWERS

FRESH FLOWERS FROM THE WORLD'S BEST GROWERS

The Best from Around the World
From South America to Northern Europe, Hallmark circles the globe in search of the most exclusive varieties. Our growers cultivate the finest blossoms within their region. And now these unique blossoms are all available in one location: the Hallmark World Flower Market.

We send them straight from the fields to your doorstep.
Imagine a kaleidoscope of exquisite blossoms just reaching their peak. Because we ship them right after they're cut, these hand-selected flowers arrive fresher and last longer. What's more, they're arranged in an elegant bouquet, and sent to you in a specially designed beautiful Hallmark gift box.

Hallmark cares
For beautiful, long lasting flowers, follow the simple suggestions and tips described in **flower care**. We know that you'll enjoy your visit to Hallmark Flowers and that any questions you may have will be addressed by our **customer care**. We further guarantee that your flowers will arrive on time and in perfect condition. See **gift box and shipping** for details.

More Questions?
If you have any other questions about our flowers or would like to order by phone, please call 1-800-HALLMARK (1-800-425-5627).

To see our variety of bouquets, choose from the list to the left.

>> Background on the Hallmark flower business is available on the site.

FLOWER CARE

For beautiful,
long lasting flowers,
follow these simple steps:

1. Pour cool water and flower food into a clean vase.

2. Unwrap the flowers and place the stems in a sink or bowl of water. Carefully cut half inch off the end of each stem with a sharp knife or scissors. Remove any leaves that may fall below the water line. Foliage will discolor water and promote disease.

3. For best results, re-cut the stems, change the vase water, and add flower food every three to four days. Keeping the flowers out of direct sunlight or drafts will help extend their life as well.

These simple flower care steps will also be included in the gift box, sent to your recipient.

Additional Flower Tips:

- When cutting the flowers, try not to "saw" the flowers, making a clean cut of the stem instead.

- Do not display flowers on top of appliances that give off heat, (i.e. televisions, stereos.)

- Cut the stems at a slight angle, as this will give more surface area to absorb water.

- Do not cut the flowers with a dull blade. Using a dull knife or scissors will crush the vessels in the stem which allow the flower to drink. If the flower can't take in water, it will die quickly.

- A clean vase should be used for all flowers. Wash and rinse all vases before use to get rid of bacteria and residue that can harm flowers.

- Do not store flowers near fresh fruit. Fruit emits ethylene gas, which is harmful to flowers and kills them prematurely.

- All flowers should be cut underwater. Cutting flowers underwater prevents air from entering the stem after it is cut. If air gets into the stem, it can cause a blockage in the stem and prevent the flower from drinking.

- If you receive roses in your bouquet, you can pluck off a few of the outer petals if they are discolored. These are called "guard" petals and help protect the flower during shipping.

- If you receive lilies in your bouquet, be careful of the stamens inside the flower because they can stain fabric. The stamens are the long yellow part of the flowers. If a piece of fabric does get stained, use clear tape to pick the stain up off the fabric. Don't rub the stain.

- Old tricks of the trade, such as putting an aspirin, a penny, or sugar in the vase water serve the same purpose as flower food. They give the flower nutrients and kill harmful bacteria as well.

- Don't be afraid to handle the flowers. You don't have to be too gentle with them as they have traveled a long way . and can take some abuse. Don't be afraid to redesign your bouquet.

- If for some reason you need to cancel or change an order, please call 1-800-HALLMARK. Due to the speed of our delivery process, we will not be able to respond fast enough via email.

>> Helpful hints on flower care help make the most of a beautiful bouquet.

The real beauty of the Hallmark World Flower

Market website is its simplicity.

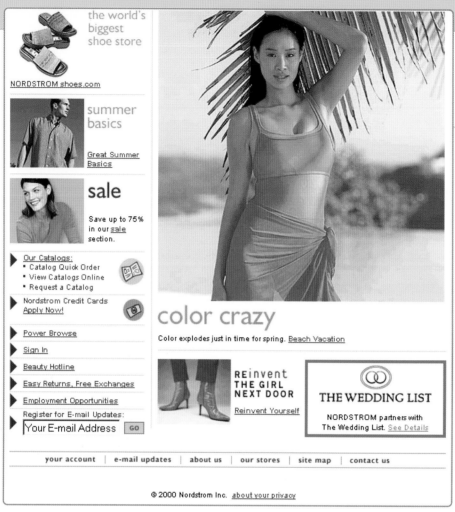

>> A simple and bright home page welcomes the user to the Nordstrom.com site.

The Best in Quality Fashion Goods and Services Online

- Focus on navigation.
- Always ask, "How will this affect the customer?"
- Don't lose the brand in the technology.

03

Nordstrom

With hundreds of thousands of SKUs and an additional offering of more than 20 million pairs of shoes, Nordstrom.com and Nordstromshoes.com rely on transparent navigation to help customers find the items they're looking for. Instead of superimposing a single architecture on the site, Nordstrom allows customers to choose the way they want to shop. Multiple options for searching and sorting make an otherwise mind-boggling site easy to surf and shop.

How They Do It

All the merchandise on the Nordstrom.com site is divided into tabs: women, men, shoes, jewelry, gifts, sale, and featured items. Within each tab are more directional cues that connect customers with merchandise to fit their shopping objective, such as "trends" or "your style." In addition, for focused shoppers, Nordstrom has Power Browse, an incredible search engine that selects merchandise based on the customer's preferences. This feature allows users to pinpoint exactly the right merchandise without clicking through lots of pages.

At Nordstomshoes.com, customers may browse men, women, kids, trends, and brand stores or search for a particular size, color, brand, or width. All of these options make sorting through millions of shoes a breeze; users don't have to look at anything they aren't interested in. Innovative use of a frame at the bottom of the screen lets users search, view their picks, shopping bag and account information, or contact customer service, all without leaving the item currently selected.

The Catalogs

The integration of Nordstrom's catalogs into the website offers another customer-friendly feature in this already extensive operation. Customers may order items featured in a catalog, request a catalog, or actually view a number of catalogs online.

Visual Design

It's not just the amazing navigation options that make Nordstrom.com so strong; the essential graphic design makes the merchandise stand out. Muted, natural colors, maximized white space, and small fonts all bring the focus to the products, not the site itself.

Nordstrom, Inc.: 1617 Sixth Avenue, Seattle, WA 98101-1742, (888) 282-6060

Executives: Paul Onnen, Executive Vice President and Chief Technology Officer; Kathryn Olson, Executive Vice President, Marketing; Bob Schwartz, Executive Vice President and General Manager, E-Commerce Design Team: Chris Dressler, Group Program Manager; Pamela Perret, Managing Director, Internet Toolbox: Microsoft Windows 2000, Photoshop, Illustrator, Streamline

>> Neutral and very small, the navigation bar can take users anywhere on the site.

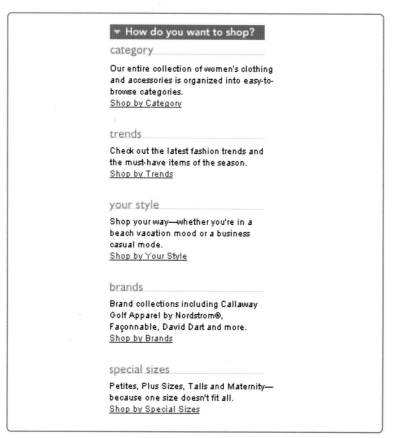

▼ How do you want to shop?

category

Our entire collection of women's clothing and accessories is organized into easy-to-browse categories.
Shop by Category

trends

Check out the latest fashion trends and the must-have items of the season.
Shop by Trends

your style

Shop your way—whether you're in a beach vacation mood or a business casual mode.
Shop by Your Style

brands

Brand collections including Callaway Golf Apparel by Nordstrom®, Façonnable, David Dart and more.
Shop by Brands

special sizes

Petites, Plus Sizes, Talls and Maternity—because one size doesn't fit all.
Shop by Special Sizes

>> Nordstrom allows customers to choose how they want to shop the site.

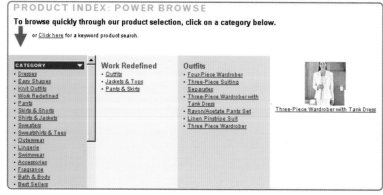

PRODUCT INDEX: POWER BROWSE

To browse quickly through our product selection, click on a category below.

or Click here for a keyword product search.

CATEGORY
- Dresses
- Easy Shapes
- Knit Outfits
- Work Redefined
- Pants
- Skirts & Shorts
- Shirts & Jackets
- Sweaters
- Sweatshirts & Tees
- Outerwear
- Lingerie
- Swimwear
- Accessories
- Fragrance
- Bath & Body
- Best Sellers

Work Redefined
- Outfits
- Jackets & Tops
- Pants & Skirts

Outfits
- Four-Piece Wardrober
- Three-Piece Suiting Separates
- Three-Piece Wardrober with Tank Dress
- Rayon/Acetate Pants Set
- Linen Pinstripe Suit
- Three Piece Wardrober

Three-Piece Wardrober with Tank Dress

>> The Power Browse feature cuts down on surfing for customers who know what they want.

- **Website Objective:** To provide the best possible online shopping experience for customers.
- **Creative Strategy:** Create a compelling and engaging environment that helps customers quickly find the right item.
- **Target Audience:** Women and men who love shoes, fashion, accessories, and apparel.

>> The Nordstromshoes.com interface allows users to view product and search for other footwear at the same time.

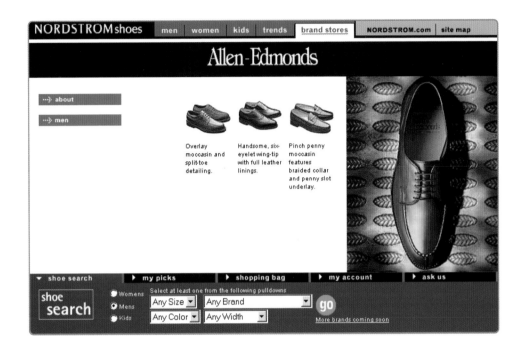

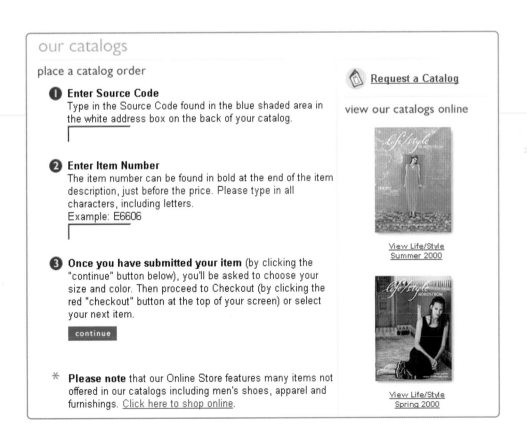

our catalogs

place a catalog order

1 Enter Source Code
Type in the Source Code found in the blue shaded area in the white address box on the back of your catalog.

2 Enter Item Number
The item number can be found in bold at the end of the item description, just before the price. Please type in all characters, including letters.
Example: E6606

3 Once you have submitted your item (by clicking the "continue" button below), you'll be asked to choose your size and color. Then proceed to Checkout (by clicking the red "checkout" button at the top of your screen) or select your next item.

[continue]

* **Please note** that our Online Store features many items not offered in our catalogs including men's shoes, apparel and furnishings. Click here to shop online.

▢ **Request a Catalog**

view our catalogs online

View Life/Style
Summer 2000

View Life/Style
Spring 2000

>> Customers can purchase catalog items online, request a catalog, or view current catalogs.

>> The beauty hotline links customers to articles on beauty trends and personal beauty shoppers.

>> Exclusive Nordstrom products, such as fragrances, warrant special features.

reinvent yourself

- ▶ REINVENT THE POWER SUIT
- ▶ REINVENT THE GIRL NEXT DOOR
- ▶ REINVENT SOCCER MOM
- ▶ REINVENT THERAPY
- ▶ REINVENT THE HEIRLOOM
- ▶ REINVENT PAJAMAS

REinvent
THE POWER SUIT
◀ Loosen Your Tie

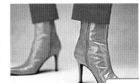

REinvent
THE GIRL NEXT DOOR
Walk on the Wild Side ▶

REinventTHE HEIRL...
◀ Raid Our Jewelry Box

REinventTHERAPY
Session Starts Here ▶

REinventPAJAMAS

>> Featured products are grouped by theme with intriguing text and images.

REinventPAJAMAS

Indulge yourself.

6mm Faux Pearl Strands
$19.00 - $35.00

Pearl Cross Necklace
$55.00

Pearl Bracelet
$125.00

Cultured Pearl Earrings, 7mm
$150.00

Tahitian Pearl & Pave Diamond Ring
$2,960.00

Scott Kay Platinum & Pearl Earrings
$920.00

Freshwater Pearl & Silver Bracelet
$68.00

Freshwater Pearl Ring
$28.00

8mm Faux Pearl Strands
$20.00 - $36.00

Carolee Curly Chain Necklace
$40.00

Carolee Drop Earring
$25.00

Carolee Illusion Necklace
$40.00

Cultured Pearl Earrings, 6mm
$110.00

>> Close-up images of products and prices are linked to detailed product pages.

Muted, natural colors, maximized white space, and small fonts all bring the focus to the products.

Nordstrom allows customers to choose the way they want to shop.

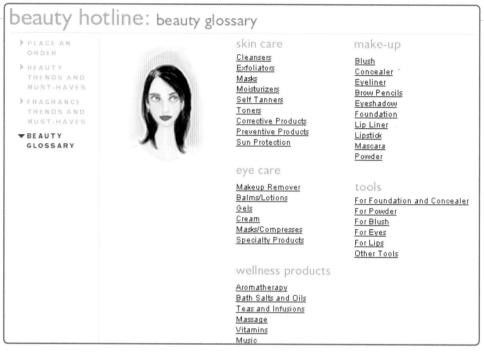

>> A beauty glossary helps the cosmetically challenged understand what all those terms mean.

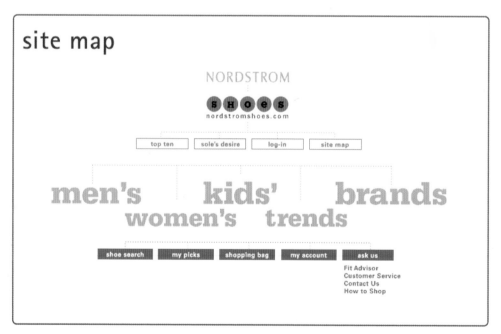

>> The bright, easy-to-understand site map helps customers navigate the site.

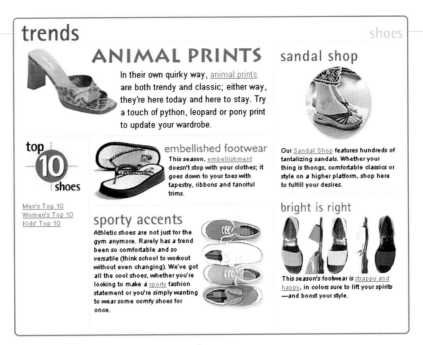

trends

ANIMAL PRINTS

In their own quirky way, animal prints are both trendy and classic; either way, they're here today and here to stay. Try a touch of python, leopard or pony print to update your wardrobe.

sandal shop

Our Sandal Shop features hundreds of tantalizing sandals. Whether your thing is thongs, comfortable classics or style on a higher platform, shop here to fulfill your desires.

top 10 shoes

Men's Top 10
Women's Top 10
Kids' Top 10

embellished footwear

This season, embellishment doesn't stop with your clothes; it goes down to your toes with tapestry, ribbons and fanciful trims.

bright is right

This season's footwear is strappy and happy, in colors sure to lift your spirits —and boost your style.

sporty accents

Athletic shoes are not just for the gym anymore. Rarely has a trend been so comfortable and so versatile (think school to workout without even changing). We've got all the cool shoes, whether you're looking to make a sporty fashion statement or you're simply wanting to wear some comfy shoes for once.

>> Fun text and colors highlight the latest trends in footwear.

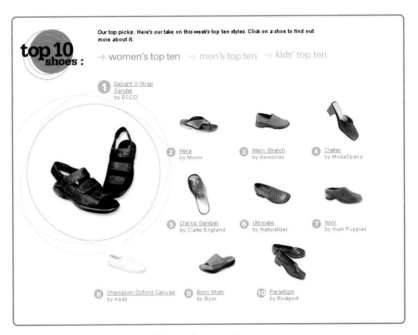

top 10 shoes :

Our top picks. Here's our take on this week's top ten styles. Click on a shoe to find out more about it.

⇢ women's top ten ⇢ men's top ten ⇢ kids' top ten

1. Delight 3-Strap Sandal by ECCO
2. Hera by Munro
3. Main Stretch by Aerosoles
4. Clatter by ModaSpana
5. Clarks Sanibel by Clarks England
6. Ultimate by Naturalizer
7. Anni by Hush Puppies
8. Champion Oxford Canvas by Keds
9. Born Wish by Born
10. Paradigm by Rockport

>> Nordstrom's top ten picks for women's shoes change weekly.

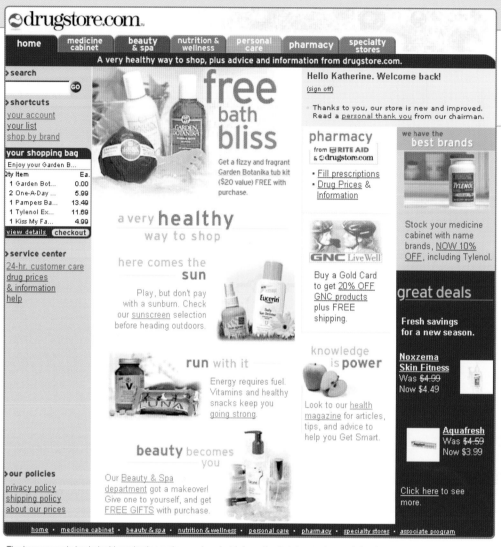

>> The home page is loaded with navigation options and product information but does not overwhelm the customer.

A Very Healthy Way to Shop

- Keep the site clean and uncluttered.
- Group products together in logical ways.
- Keep shopping fun and engaging.

04
drugstore.com

The Balancing Act

"Our site has more than 18,000 products, more than brick-and-mortar drugstores by far," says Denise Trabona, design director for drugstore.com. This vast inventory calls for a careful balancing act among navigation, merchandising, and trying to keep some breathing room on the pages. "We're always striking the balance between user interface and merchandising, working to keep the site clean and uncluttered, bright and fun," she adds.

What's Important

The drugstore.com home page manages to pack in tons of information without feeling too crowded. Users can search for a specific product, choose one of six departments, or peruse the featured specials and products. Once customers jump to a specific department, such as nutrition and wellness or personal care, a new color scheme identifies that department while maintaining the same format as the rest of the site. In addition, an online magazine is integrated into each department, so when users are shopping for beauty products, articles on the latest trends in color or the best products to protect the face from the sun are easily accessible.

One of the most helpful features on the site is the shopping bag. Once a user selects a product to purchase, a brief summary of the product and its price appear on the left side of the screen and stay there throughout the shopping experience, even reappearing at the next visit if the user doesn't check out before leaving the site. Customers can also access previous lists to check on their status or to make reordering items easier.

Getting Organized

Beyond the six departments in drugstore.com, items are grouped together in categories, just like at the corner drugstore. Thus, all the pain relievers are in one area and all the cold remedies are listed together in another, making it easy to log on, get what is needed, and get on with the day. Checkout is a breeze, with easy-to-follow directions and minimal graphics.

drugstore.com, Inc.: 3150 139th Ave SE, Suite 100, Bellevue, WA 98005, (425) 372-3200

Executives: Peter Neupert, President and CEO; Kal Raman, Senior Vice President and CIO; Mark Silverman, Vice President, Business Development, David Rostov, Vice President and CFO; Chris Hauser, Vice President of Operations **Design Team:** Denise Trabona, Design Director **Toolbox:** Photoshop, Illustrator, ImageReady

16 17 18 19 20 21 22 23 24 25 26 27 28 29 30

One of the most helpful features is the shopping bag.

shopping bag

When you've made your final selections and placed them in your Shopping Bag, click Checkout to start placing your order. Standard 2-4 Days shipping is $3.95 per order. About our shipping prices

Continue Shopping **checkout**

If you make changes, click here to adjust your total: **update quantity**

PRODUCT NAME	QTY	DELETE	SIZE	PRICE	TOTAL
SPECIAL: Enjoy your Garden Botanika Tub Kit!					
One-A-Day Maximum, Multivitamin/Multimineral Tablets	2	🗑	60 ea	$5.99	$11.98
Pampers Baby Dry Diapers Unisex, Size 4 (22-37 lbs)	1	🗑	48 ea	$13.49	$13.49
Garden Botanika Free Gift	1		1 ea	$20.00 Now $0.00	$0.00
Tylenol Extra Strength Caplets, Pain Reliever & Fever Reducer	1	🗑	250 ea	$11.69	$11.69
Kiss My Face Active Enzyme Scented Stick Deodorant	1	🗑	1.7 fl oz	$4.99	$4.99

>> Shopping bag details allow users to edit contents even before checking out.

Get Smart / back to: **personal care**

GET smart PERSONAL CARE EDITION

let the tub games begin

Getting kids into the bath shouldn't be so hard. See our tub tips to make bath time more like playtime.

bottoms up

Babies live in diapers. If they could, they'd tell you which ones to choose.

"For better brushing, replace your toothbrush with every change of season."

from American Dental Association

bask in sun smarts

personal care information
> **pregnancy and infant center** Expecting? Special articles, quizzes, and shopping tips for you.

> **buying guides** We've done the research to help you make informed buying choices.

> **sun care advisor** Sun care products are not all the same. Our Sun Care Advisor helps you find ones that match your skin type and lifestyle.

perfect match

Find the right products to touch your skin--before the sun does. Our Sun Care Advisor can help.

smooth curves ahead

Spring is here. As you prepare to bare, find the easiest ways to remove hair.

>> Online magazines for each department add relevant copy and product reviews.

- **Website Objective:** To be everyday champions for healthy living.
- **Creative Strategy:** Make it a fun, memorable shopping experience, while keeping it easy to use.
- **Target Audience:** Women, ages 25–54.

A persistent mini-shopping bag stays on the left-hand side of the screen throughout the shopping process.

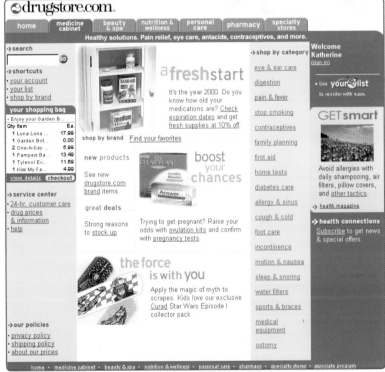

Separate color schemes for each department and items divided by category make finding the right product easy.

Checkout is a breeze.

Our site has more than 18,000 products, more than brick-and-mortar drugstores by far.

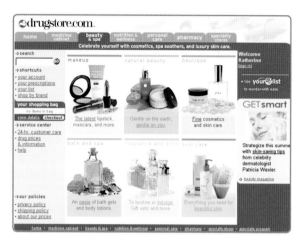

>> Pastel hues accent the beauty and spa center

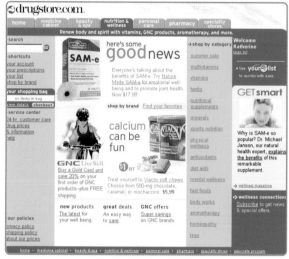

>> The nutrition and wellness area features products ranging from vitamins to aromatherapy.

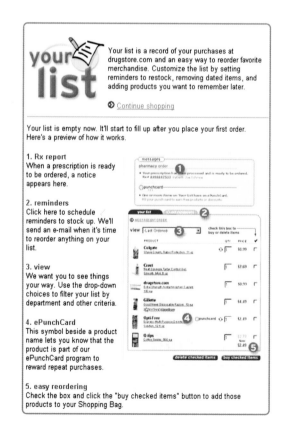

your list

Your list is a record of your purchases at drugstore.com and an easy way to reorder favorite merchandise. Customize the list by setting reminders to restock, removing dated items, and adding products you want to remember later.

Continue shopping

Your list is empty now. It'll start to fill up after you place your first order. Here's a preview of how it works.

1. Rx report
When a prescription is ready to be ordered, a notice appears here.

2. reminders
Click here to schedule reminders to stock up. We'll send an e-mail when it's time to reorder anything on your list.

3. view
We want you to see things your way. Use the drop-down choices to filter your list by department and other criteria.

4. ePunchCard
This symbol beside a product name lets you know that the product is part of our ePunchCard program to reward repeat purchases.

5. easy reordering
Check the box and click the "buy checked items" button to add those products to your Shopping Bag.

>> A record of customers' purchases makes repeat visits and purchases faster and easier.

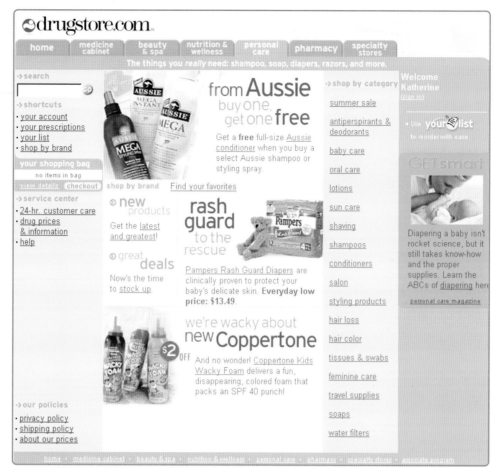

Seasonal items like sunscreen are featured in the personal care area.

The drugstore.com pharmacy allows customers to fill prescriptions online.

The specialty stores include items like natural products and baby gifts.

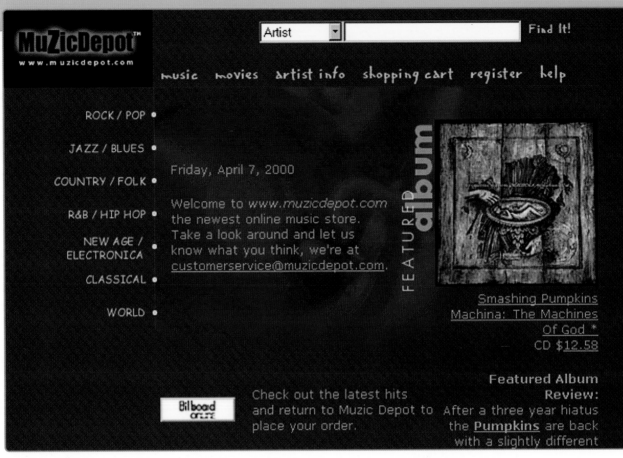

Artist ▾ [] **Find It!**

music movies artist info shopping cart register help

ROCK / POP •

JAZZ / BLUES •

COUNTRY / FOLK •

R&B / HIP HOP •

NEW AGE /
ELECTRONICA •

CLASSICAL •

WORLD •

Friday, April 7, 2000

Welcome to *www.muzicdepot.com*
the newest online music store.
Take a look around and let us
know what you think, we're at
customerservice@muzicdepot.com.

FEATURED album

Smashing Pumpkins
Machina: The Machines
Of God *
CD $12.58

Billboard
online

Check out the latest hits
and return to Muzic Depot to
place your order.

Featured Album
Review:
After a three year hiatus
the **Pumpkins** are back
with a slightly different

>> The home page is rich but not overwhelming, drawing attention to the featured album.

The Best Prices on the Planet

- Use colorful art in an uncomplicated design.
- Give users various entertainment and customization options.
- Make the user profile piece easy and inviting to use.

05
MuZicDepot.com

Another Online Music Store

Competition is fierce among online music/video/DVD retailers. The big challenge for MuZicDepot was finding a way to stand out in a crowded market while maintaining the ability to provide CDs, tapes, and videos at significantly discounted prices. Their solution: Improve shopping capability but maintain an atmosphere of fun and simplicity.

What's Important

People want to be able to find the music or video they want, so MuZicDepot makes the search function available on every page. The focus of the content is providing the essential information to customers, not overwhelming them with editorial information. But when a user wants more, it's all there for the taking—extensive biographies, music news, album notes and reviews, complete track listings, and a real-time recommendation engine.

Beyond making layers of information readily accessible to the user, the MuZicDepot site goes out of its way to provide helpful customer service. With one of the most straightforward and detailed FAQs (frequently asked questions) on the Internet and live customer service chat available six days a week, MuZicDepot users are well taken care of from browsing through delivery.

Putting It All Together

"The real challenge in building this site was in the integration of so many third-party applications and databases," notes Bill O'Neil of xalient.com, the design company hired by MuZicDepot to address the challenge. The core site uses MUZE for the main music and video database, ENZO for the sound files database, and Valley for fulfillment and real-time inventory and availability data. On top of these components are custom functions like NetPerceptions for the recommendation engine and Verity to enhance the search functions, and custom applications like the profile registration application and a content management system Intranet.

What pulls all this together is fun graphics, good colors, and award-winning usability. Adds O'Neil, "At the end of the day, we want all of these technologies to be transparent to the users. Their only concern should be to enjoy their shopping experience. I think we have achieved that with MuZicDepot."

> **At the end of the day, we want all of these technologies to be transparent to users.**

MuZicDepot.com: 525 S. Flagler Drive, Suite 400, West Palm Beach, FL 33401, (561) 832-0026

Executives: Christian Hainsworth, CEO; Carmine DellaSala, President **Design Team:** xalient.com **Toolbox:** E-Business Application: Oracle8I, Java, CyberCash
Digital Telephony Switch: MS -SQL 7.0, VisualBasic, VisualBasic Script

16 17 18 19 20 21 22 23 24 25 26 27 28 29 30

Bon Jovi - New Jersey [Remaster]

Contact Customer Service

MuZic Search

Rock / Pop
Jazz / Blues
Country / Folk
R&B / Hip Hop
World / New Age
Classical
Soundtracks
Children's
Classic Rock
RiZing Stars
Electronica / Dance
Christian / Gospel
Latin
Oldies

Movie Search

Action / Adventure
Children's
Classics
Comedy

CD **$9.58** - **List Price $11.97** 20% Off!

Title In Stock; Usually ships within 1 Business Day

MuZic AdviZor CLICK HERE I Like **Bon Jovi**
Recommend More Music I May Like!

Shopping @ MuZicDepot.com is **safe & secure**.

album information

Producer: Bruce Fairbairn
Label: Mercury
Originally Released: 1988

of Discs: 1
Length: 57:37
Mono/Stereo: Stereo
Studio/Live: Studio

track list

1. Lay Your Hands On Me
2. Bad Medicine

7. Wild Is The Wind
8. Ride Cowboy Ride

>> The secondary pages are primarily white, allowing the user to focus on the content.

MuZic Search

Rock / Pop
Jazz / Blues
Country / Folk
R&B / Hip Hop
World / New Age
Classical
Soundtracks
Children's
Classic Rock
RiZing Stars
Electronica / Dance
Christian / Gospel
Latin
Oldies

>> Search is available on every page.

- **Website Objective:** Tackle a more significant cut of the online music store market.
- **Creative Strategy:** Use a simple approach to draw attention to the product and content.
- **Target Audience:** Web-savvy people, ages 18–45.

>> The content management intranet interface is just as clean and easy to use as the web interface.

>> In-depth information is just a click away from the product image.

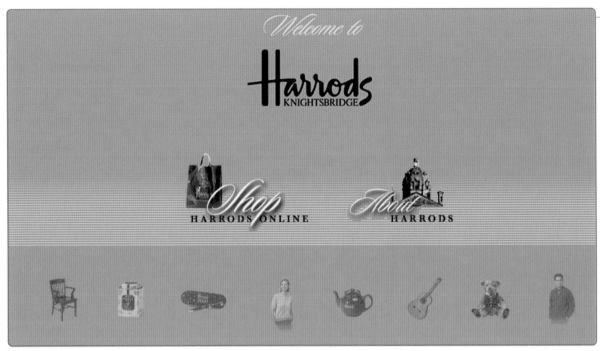

>> The distinctive Harrods label and signature green connote an elegant shopping experience.

Online Shopping Elegance

- Focus on product and its presentation.
- Emphasize navigation; customers want to know where they are.
- Design from the customer's point of view.

06
Harrods

The Store

"Our luxury products and outstanding customer service distinguish us from the competition in the real world," says Iain Jones, creative manager for Harrods.com. The same holds true of their website, where excellent navigation and customer service elements paired with an elegant shopping environment provide a delightful online shopping experience. From $40 cufflinks to $5000 pens and $15 tea to $1800 watches, Harrods caters to the extreme high end of the retail spectrum in spectacular style.

History of the Site Design

As with many developing websites, the first design ideas emerged from an IT-driven environment, but the designs didn't quite capture the rich heritage of the Harrods name. Next, a design agency took a stab at designing the site. Their results were much more in keeping with the elegance and tradition of Harrods, but the navigation and checkout functions began falling apart due to a lack of understanding of the back-end technology. Finally, the Harrods creative team settled on a design by templates from the creative agency, which they then modified to fit the technical specs of the in-house systems.

The Look and Feel

The Harrods signature green appears throughout the site in various shades and applications: subtle borders, script fonts, and text. Clean pictures and minimal but descriptive copy accompany all products. The signature Harrods shopping bag appropriately serves as the icon for the checkout area, where simple icons and straightforward text guide the user through the payment process. Everywhere on the site, the Harrods imprimatur pervades without overwhelming: brand marketing at its best.

The Challenges

Each of the thousands of products in the Harrods catalog is categorized in a variety of ways. For instance, a woman's scarf may be accessed under women's, accessories, scarves, and cashmere. This kind of indexing makes the site effortless for users but intensifies navigation details for the design team. To capitalize on the eager North American online audience, the first phase of the site was launched to U.S. and Canadian customers only. This meant that Harrods had to be prepared to work across several time zones to eliminate initial bugs and glitches.

Future Enhancements

With a firm commitment from the chairman of Harrods, improvements are planned to make the website even more like the retail store. Special designer collections will have their own mini-sites, and different departments will have subtly individual atmospheres, complete with streaming audio, three-dimensional product images, and downloadable videos of models wearing the product. "Our goal is to utilize all available technology to make the customer's shopping experience uniquely Harrods," says Jones.

Harrods Online: Harrods, Brompton Road, London SW1X 7XL, 0171-730 1234

Executives: Don Norman, CEO Harrods Online **Design Team:** Iain Jones, Creative Manager
Toolbox: Photoshop, DreamWeaver, Flash, Vignette

Harrods caters to the extreme high end of the retail spectrum in spectacular style.

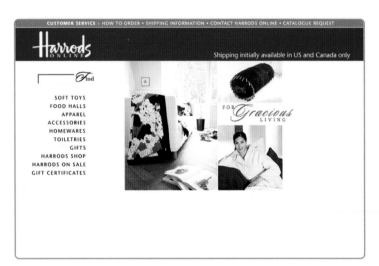

>> The home page features all the site's strengths: clean navigation, elegant environment, and luxury products.

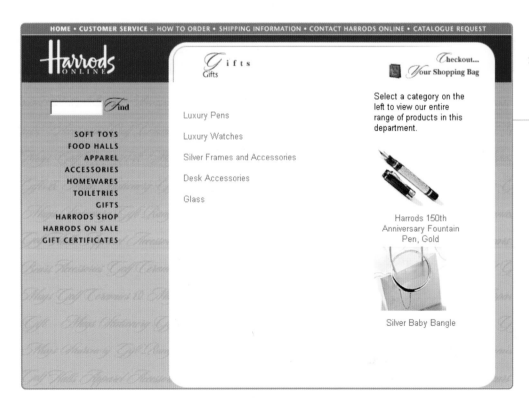

>> Finding the perfect gift or luxury item is simplified with cross-indexing, allowing the shopper to find the item in several different locations.

- **Website Objective:** To be the world's leading online retailer of luxury merchandise and brands.
- **Creative Strategy:** Focus on the product and its presentation. Provide clean navigation and excellent customer service elements.
- **Target Audience:** Upscale, but as wide a market as possible.

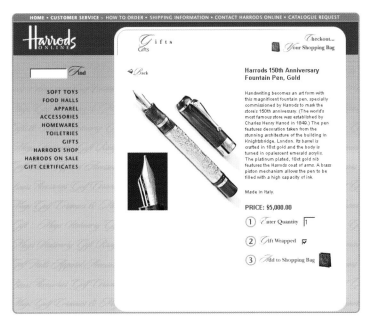

>> Sharp product images, with close-ups as necessary, give the shopper an excellent sense of the complete product.

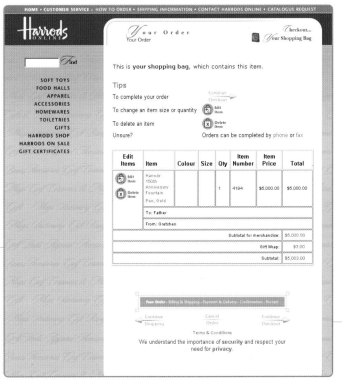

>> A straightforward checkout page directs customers through the process.

Our goal is to utilize all available technology to make the customer's shopping experience uniquely Harrods.

Harrods ONLINE

Customer Service
Catalogue Request

Checkout...
Your Shopping Bag

Complete this form to **receive a copy** of the Harrods ONLINE catalogue.

Please note that Harrods ONLINE catalogues can be sent to **US and Canadian** addresses only.

*Indicates required information

*First Name:

Middle Initial:

*Last Name:

*Address1:

Address2:

*City:

*State/*Province:

*Zip/*Postal Code:

*Country: United States

Phone:

Email:

Submit Your Request

SOFT TOYS
FOOD HALLS
APPAREL
ACCESSORIES
HOMEWARES
TOILETRIES
GIFTS
HARRODS SHOP
HARRODS ON SALE
GIFT CERTIFICATES

>> Harrods offers an online catalog to further enhance the unique shopping experience and promote return shoppers.

>> Distinct departments and products allow intuitive navigation.

>> All relevant product information is presented at one time, including a gift-wrap option.

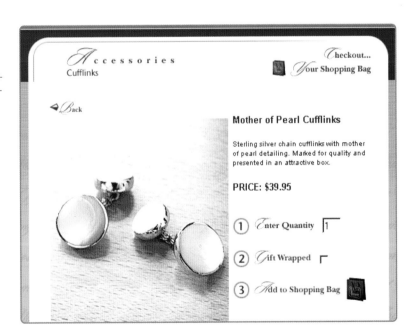

Everywhere on the site, the Harrods imprimatur pervades without overwhelming: brand marketing at its best.

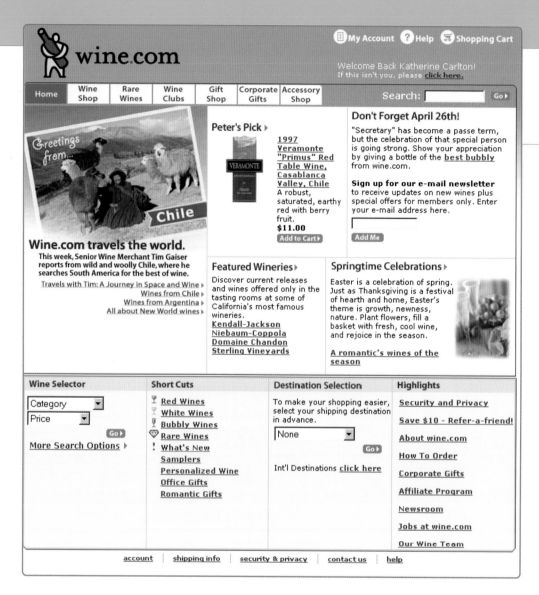

Making Wine Fun and Accessible

- Display the products accurately.
- Make it easy for all audiences to sort and navigate.
- Keep the technology appropriate to the audience and the product.

07
wine.com

Selecting wine can be an overwhelming experience. The terminology is intimidating on its own: Gamay? Malolactic fermentation? Malvasia? Then, which wines go with which foods? Can you really get a good bottle of wine for under $10? A visit to wine.com answers these questions and takes the fear out of the wine-buying process for the novice while providing the wine aficionado with the best wines and information available anywhere.

The Challenge

"We're a pretty small design team, so we're constantly trying to adapt to the changing website and our growing audience," said Amanda Sava, manager of website design and production for wine.com. "In the past several months, we've added hundreds of new wines, improved our search technology, and expanded the scope of the site to include several new sections."

For Sava, the biggest frustration in all these changes is making all the new information and features fit in the current design templates. "Our target is always moving and we're constantly working to make it all work in the current structure. Right now we're dealing with a lack of flexibility in templating. Sometimes it's difficult to get as much as you want above the fold," she adds.

What Makes It Work

Quick access to search functions for the experienced user, friendly text on the wines for the average wine buyer, plus simple icons make the wine.com interface easy to understand. Helpful shortcuts to current specials and notable bargains allow customers to make purchases quickly. There's also a wish-list component that allows users to save information on wines to a private area for future reference or purchase. Once registered, checking out is a simple process, even affording users the option to gift-box individual bottles and ship them to separate addresses.

" Sometimes it's difficult to get as much as you want above the fold. "

wine.com: 650 Airpark Road, Suite D, Napa, CA 94558, (707) 265-2860

Executives: William Newlands, President and Chief Executive Officer; Kathy Cruz, Chief Technology Officer; Rob Jennings, Senior Vice President of Content and Programming **Design Team:** Amanda Sava, Manager of Website Design and Production; Kate McPherson, Senior Website Producer; Min Yan, Website Producer
Toolbox: DreamWeaver, Text editors, JavaScript

16 17 18 19 20 21 22 23 24 25 26 27 28 29 30

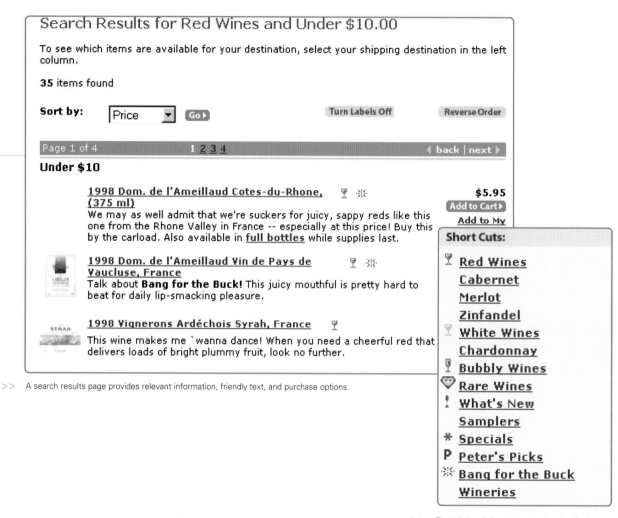

Search Results for Red Wines and Under $10.00

To see which items are available for your destination, select your shipping destination in the left column.

35 items found

Sort by: [Price ▼] [Go ▶] Turn Labels Off Reverse Order

Page 1 of 4 1 2 3 4 ◀ back | next ▶

Under $10

1998 Dom. de l'Ameillaud Cotes-du-Rhone, (375 ml) ♏ ※ $5.95
[Add to Cart ▶]
We may as well admit that we're suckers for juicy, sappy reds like this Add to My
one from the Rhone Valley in France -- especially at this price! Buy this
by the carload. Also available in **full bottles** while supplies last.

1998 Dom. de l'Ameillaud Vin de Pays de Vaucluse, France ♏ ※
Talk about **Bang for the Buck!** This juicy mouthful is pretty hard to
beat for daily lip-smacking pleasure.

1998 Vignerons Ardéchois Syrah, France ♏
This wine makes me `wanna dance! When you need a cheerful red that
delivers loads of bright plummy fruit, look no further.

Short Cuts:

♏ **Red Wines**
Cabernet
Merlot
Zinfandel
♏ **White Wines**
Chardonnay
♏ **Bubbly Wines**
◈ **Rare Wines**
! **What's New**
Samplers
✳ **Specials**
P **Peter's Picks**
※ **Bang for the Buck**
Wineries

>> A search results page provides relevant information, friendly text, and purchase options.

>> The left-hand shortcut navigation bar features
 simple icons used throughout the site.

" **Helpful shortcuts to current specials and notable bargains allow**

customers to make purchases quickly. **"**

- **Website Objective:** To provide wine enthusiasts on every knowledge level with detailed information on wines from all over the world.
- **Creative Strategy:** Make the merchandise as accessible as possible.
- **Target Audience:** 25–55-year-old food and wine enthusiasts.

Winespeak Redefined

In the Old World and the New World, from Spain to Chile, wine is the international language of hospitality and entertaining. Loosely speaking, "wine" translates to "conviviality," "new friendships," "good food," and "fun." It's the easiest language to learn in the world.

Wine.com's Iberian Nights Gift Pack ▸

>> Bright, accurate images and immediate access to checkout speed the shopping experience for the customer.

Sweets ▸

Merlot and Chocolate
Marvelous Merlot paired with decadent chocolate.

$24.00

Add to Cart ▸

Great Gifts

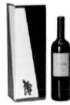

A Great Bottle of Red (in a wine.com gift box)
A delicious, flavor-packed field blend.
$19.00
Add to Cart ▸

Gift Packages

Portable Pair
An Australian wh
and a Rhone Val
red..to go!
$28.00
Add to Cart ▸

wine.com | My Account | Help | Shopping Cart
Home | Wine Shop | Rare Wines | Wine Clubs | Gift Shop | Corporate Gifts | Accessory Shop | Search: | Go ▸

>> A simple, compact navigation bar makes it easy to get around but takes up little valuable screen space.

Shopping Cart

Your current destination is **California**. If you are shipping to another state, please change your state selection using the pull down menu on the lower left hand side of this page.

Purchases	qty	del	price/item	total
1997 d'Arenberg "d'Arry's Original" Shiraz/Grenache, Australia	1	🗑	$15.50	$15.50
1997 Kendall-Jackson Vintner's Reserve Merlot, California	1	🗑	$18.00	$18.00
10% Case Discount				$0.00
Sub-total				$33.50
Sales Tax				$2.60
Shipping				$5.40

Update Cart Empty Cart

Enter Coupon or Certificate Number Here and Click Enter [] Enter

Total **$41.50**

Is this a gift? ⦿ yes ◯ no

Continue Shopping Checkout ☑

>> A no-frills, well-integrated shopping cart is the last stop before final purchase.

Home Schooling

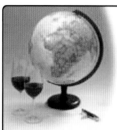

Our wine clubs are all about deepening your enjoyment of wine by increasing your understanding of it. Each club includes appropriately selected wines and tasting materials - delivered right to your door.

- Classic Cellars
- Discovery Club
- Crystal Wine Club
- Wines of the World

Discovery Club

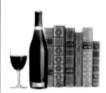

Discover the fun of learning about wine. Learn as you taste with a coordinated program of wine selections and educational materials.
Starts at $27.50/month

Wines of the World

Explore the world of wine with monthly selections from around the globe. Learn about each month's featured region as you enjoy its wine.
Starts at $39.50/month

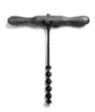

Classic Cellars

Taste exceptional wines from artisanal wineries around the world. Includes wines for your cellar and selections for drinking now!
Starts at $79.50/month

Crystal Wine Club

Explore the world of wine with two elegant Riedel crystal wine glasses in the Crystal Wine Club.

Wine Clubs

Experience the pleasure of wine delivered right to your doorstep every month! We offer several different clubs to suit your taste and your pocketbook. Let your adventures with wine begin!

Wine Club Information

Shipping and applicable taxes are not included in the stated price

If you enroll prior to the 5th of the month, your first shipment will be delivered during the 3rd or 4th week of that month. If you enroll after the 5th of the month, the program will begin the following month.

Your introductory package includes a tasting note outline, glossary, food & wine pairing information, an elegant binder or box for storing your information and much more!

>> Wine.com provides a wide spectrum of wine clubs.

Corporate Gifts
With *Style*

Great gifts are good business. Order gifts of wine for your company, alumni group, customers, or organization to create a good impression that lasts. Be sure to check out our custom labelling options.

Etched Bottles

Unique and sophisticated (not to mention cool), etched bottles are ideal for corporate gifts or to commemorate a special event.

Gift Certificates

Always appreciated and a perfect, convenient way to say thank you, wine.com's Gift Certificates make your gift-giving easy.

Wine Clubs

A membership in one of wine.com's Wine Clubs is the perfect business gift. Every time a new bottle of wine arrives at the door, it will pleasantly remind the recipient of you and your company.

Hang Tags

When you don't have time to wait for custom bottle etching, silk-screening, or private labeling, wine.com's personalized hangtags provide a thoughtful and elegant touch.

Silk Screen Bottles

Silk screened wine bottles displaying your special message and logo are a token of appreciation that really is appreciated.

Custom Labels

The promotional possibilities are endless! Create your own design with your logo and a special message.

Corporate Gifts From wine.com

Corporate Gifts from wine.com are all about celebration, congratulation, and appreciation. Wine is a time-honored gift, a compliment to the recipient and the giver. Our custom bottles are a pleasant permanent reminder of you, your company, and the occasion.

Our commitment begins with a clear understanding and appreciation of the unique nature of a corporate order. We are dedicated to providing you with gifts of outstanding quality and value, gifts that will be truly appreciated by the recipient and that reflect well on you, the giver.

Learn more.

To speak to a corporate gift representative please contact us at: 1-877-843-5301 x244 or e-mail: corpgift@wine.com.

Corporate gifts comprise another aspect of the wine.com business.

Etched Bottles

Let wine.com help you celebrate the launch of a new product, an IPO, revenue milestone, or any special occasion with your own custom-designed bottles of fine wine. The wine enhances the moment; the engraved and painted bottles make the moment last, providing a permanent reminder of you and the occasion.

Unique and sophisticated (not to mention cool), etched and painted bottles are ideal corporate gifts or mementoes of a special event. Your logo and message are deep etched directly into the glass and then hand painted, creating a unique and beautiful gift, and demonstrating to your recipient that you care enough to give the best.

Etched Bottles Program Details

Set-up charge	$75.00
Art work area	4¼ X 4¼ maximum
Art work requirements	.eps format via e-mail (is preferred), 300 dpi, art image in a 5x5 scale
Minimum Quantity	48 bottles per design
Lead-time	4 to 6 weeks from sign-off of art work
Transit time	Varies depending on location

Standard Pricing - 750ml bottles

Bottle Quantity	Engraved One-color	Engraved Two-color	Engraved Three-color
48-120	$29.00	$32.00	$37.00
121-300	$25.00	$28.00	$33.00

More than 300 bottles and/or four color designs will be quoted individually based on the complexity and color scheme.

Prices quoted include Virtual Vineyards, Merlot, or Virtual Vineyards Chardonnay.

To engrave other selections please contact 1-877-843-5301 x244.

>> Details and requirements for corporate gifts are clearly delineated.

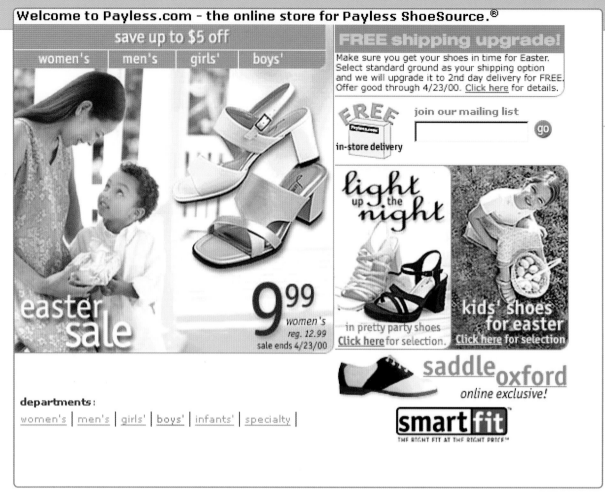

>> The homepage features the same specials that can be found in the Payless stores.

Completely Customer Driven

- Know what your audience likes about your product.
- If you have brick-and-mortar stores, keep the online experience similar.
- Don't dramatically change the look of the site unless it's an obvious improvement for the customer.

08
Payless ShoeSource

Genesis of the Site

Before launching an online presence, Payless ShoeSource took a long, hard look at what makes their 4,414 shoe stores so successful. The answer: self-selection, separating product by gender and size, and allowing customers to know what styles are in stock in what sizes. The mission of the online store became just that: create an environment as much like the in-store experience as possible.

Satisfying the Customer

"We believe that our customers will expect to have access to the terrific Payless ShoeSource brand of footwear anytime, anywhere, at their convenience," said Rhonda Wells, director of e-commerce for Payless. "And we believe they should have the ability to shop with any mix of the channels available: buy, return, exchange, shipping to their home, picking up in the store…it's all a part of making Payless as easy to use as possible."

Design Challenges

Trying to make the online experience as much like the in-person experience put unexpected constraints on the design process. As much as possible, product art on the website is the same as that in the brick-and-mortar store. The color scheme, the typeface, the promotions—all mimic the real-world experience. The site designers, who had dealt primarily with startup sites, had to adjust to working with an established business. "We had to really insist that our customers like to shop by size. And that our customers range through all age categories, not just teens," adds Wells.

Future Direction

Payless feels strongly that the Internet is about convenience. As a result, the online store will not change significantly until new technologies become available to drastically improve the online shopping experience for the customer. However, Wells is quick to point out the advantages of retailing online. "We change the graphics and offers on our site every day or week or as we see fit. If what we advertise on our site isn't selling, it comes off and more compelling products or messages go up. You don't have to print thousands of posters and consider lead time on the Internet."

Payless ShoeSource: P.O. Box 1189, Topeka, KS 66601-1189, (785) 295-6695

Executives: Steve Frazier, Vice President of Corporate Development; Keith Spirgel, Director of Strategic Planning; Rhonda Wells, Director of E-Commerce
Design Team: Organic, Inc.—user interface and non-commerce design, IBM Global Services—commerce design and commerce software Toolbox: DreamWeaver, Photoshop, HTML

16 17 18 19 20 21 22 23 24 25 26 27 28 29 30

select a size

Please choose a shoe size below. You can always come back and change sizes or categories.

Choose from all categories and sizes.

Please click a size to continue shopping.

Finding the right size

- Feet measurement tips
- Size conversion charts

Women's

| 5 | 5.5 | 6 | 6.5 | 7 | 7.5 | 8 | 8.5 | 9 | 9.5 | 10 | 11 | 12 | 13 |

>> Before the user sees any product, a shoe size must be selected. This way, only in-stock merchandise will be displayed.

Finding the right size

- Feet measurement tips
- Size conversion charts

★ **Save up to $5 off**

>> Multiple views and close-ups make buying decisions easier.

Location: Women's / Casuals / Classic

Traditional Saddle Oxford · Cable Stitch Oxford · Comfort Wedge · Low Stretch Mule

Loafer Look Mule · Casual Step-in Loafer · Woven Leather T-Strap · Bar Ornament Loafer

>> Shoe choices are displayed by gender, category, and style.

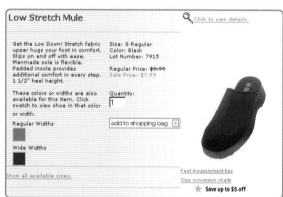

Low Stretch Mule

Click to view details.

Get the Low Down! Stretch fabric upper hugs your foot in comfort. Slips on and off with ease. Manmade sole is flexible. Padded insole provides additional comfort in every step. 1 1/2" heel height.

Size: 8 Regular
Color: Black
Lot Number: 7915

Regular Price: $9.99
Sale Price: $7.99

These colors or widths are also available for this item. Click swatch to view shoe in that color or width.

Quantity:
1

Regular Widths

add to shopping bag

Wide Widths

Show all available sizes.

Feet measurement tips
Size conversion charts
★ **Save up to $5 off**

>> Complete product information, including sale prices, is available on the individual shoe pages.

- **Website Objective:** To sell shoes at the same market share that Payless owns in the brick-and-mortar world.
- **Creative Strategy:** Create an online store that builds on the existing brand and core competencies.
- **Target Audience:** Mostly women, all ages.

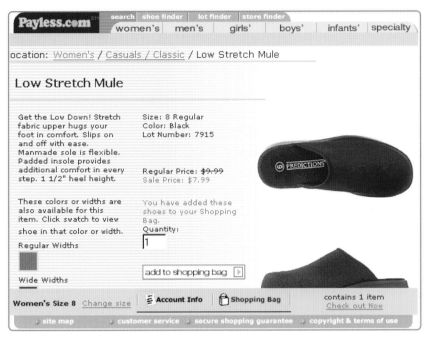

>> The navigation bar stays constant throughout the site, utilizing the same color scheme as the in-store promotions.

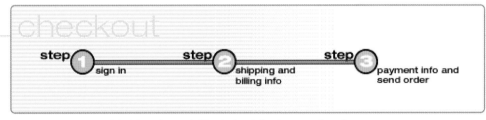

>> A graphic representation of the information needed for checkout helps the user navigate the process.

Payless customers should be able to shop with any mix of the channels available.

dis shoe sizer

Instructions for use:

To get a size for your child's foot, please print out this page and follow the instructions in the chart below.

Please note: To ensure accuracy, please measure the page with a ruler, after you print it. If the shoe sizer is too small, change the scaling in your browser's printing until you print to scale.

Put the child's heel on the chart where indicated, and measure to the end of the longest toe. If the toe is between numbers, that indicates a half size.

Infants will often curl their toes. Gently press down on the top of their foot to get an accurate foot length.

For those of you unable to print accurately, click to get measuring tips.

step 3 Your child's size is the number at the end of the largest toe. If the toe is between lines, try half sizes.

size
13 · · · 7"
12
11
10 · · · 6"
9
8
7 · · · 5"
6
5
4 · · · 4"
3
2
1
0 · · · 3"

this area = regular width | this area = wide width

Payless Shoe Source

and align foot to this edge

2"

1"

step 2

step 1 place your child's right heel along this line.

0 inch

>> A printable foot-measuring chart helps customers place accurate orders.

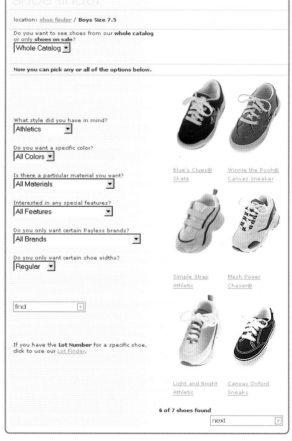

shoe finder

location: shoe finder / **Boys Size 7.5**

Do you want to see shoes from our **whole catalog** or only **shoes on sale**?
[Whole Catalog ▾]

Now you can pick any or all of the options below.

What style did you have in mind?
[Athletics ▾]

Do you want a specific color?
[All Colors ▾]

Is there a particular material you want?
[All Materials ▾]

Interested in any special features?
[All Features ▾]

Do you only want certain Payless brands?
[All Brands ▾]

Do you only want certain shoe widths?
[Regular ▾]

[find ▸]

If you have the **Lot Number** for a specific shoe, click to use our Lot Finder.

Blue's Clues® Skate
Winnie the Pooh® Canvas Sneaker

Simple Strap Athletic
Mesh Power Chaser®

Light and Bright Athletic
Canvas Oxford Sneaks

6 of 7 shoes found
[next ▸]

>> The shoe finder helps narrow the choices for the busy shopper.

store finder

The following stores are listed in order of their nearness to the address info you provided. If you have any problems, please go back to the main Store Finder page and enter different information. By clicking any of the addresses below, you can view a printable map and get driving directions from your location to the Payless ShoeSource store selected.

©2000 Vicinity Corp, GDT

next ▷

Address:	Hours:	Distance and driving direction:
TOWNE EAST SQUARE 7700 E KELLOGG DR SPACE 745 WICHITA, KS 67207-1772	10:00 am - 9:00 pm	2.4 miles Get Map/Driving Directions

Phone: 316-686-4343

Address:	Hours:	Distance and driving direction:
1514 S OLIVER ST WICHITA, KS 67218-3228	9:00 am - 9:00 pm	2.5 miles Get Map/Driving Directions

Phone: 316-683-0911

Address:	Hours:	Distance and driving direction:
POINT AT NORTHROCK 3130 NORTH ROCK ROAD #100 WICHITA, KS 67226-1311	9:00 am - 9:00 pm	3.4 miles Get Map/Driving Directions

Phone: 316-636-4148

Address:	Hours:	Distance and driving direction:
MARINA LAKES SC 2121 AMIDON AVENUE WICHITA, KS 67203-2116	9:00 am - 9:00 pm	4.7 miles Get Map/Driving Directions

Phone: 316-838-0742

Address:	Hours:	Distance and driving direction:
2548 S SENECA ST WICHITA, KS 67217-2804	9:00 am - 10:00 pm	5.4 miles Get Map/Driving Directions

Phone: 316-264-5421

Change Search	Region:	Zip/Postal Code:	
	Please select ▼		find ▷
More Specific Search	Location:	City:	
			find ▷

>> Customers can utilize the store finder to find the Payless closest to them.

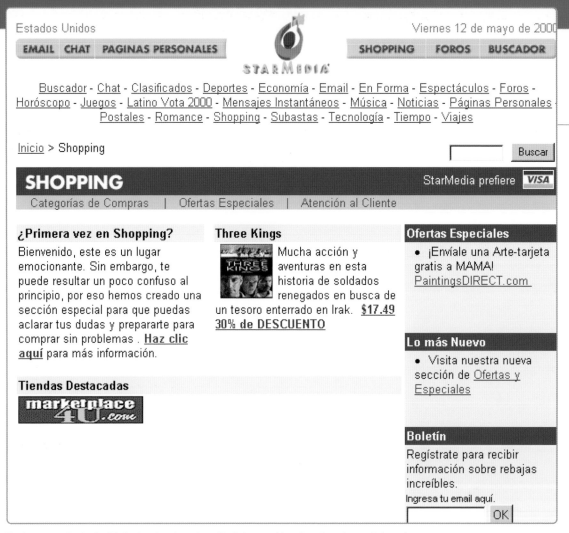

>> The home page for the StarMedia shopping channel provides links to a wide variety of vendors and information.

The Internet for Spanish- and Portuguese-speaking People Around the World

- When creating a channel environment, simplify the design elements of the host brand.
- Know the cultural customs of your customers.
- Standardize page formats to help customers feel comfortable.

09
StarMedia

What It Is

StarMedia is the leading global Internet media company for Spanish- and Portuguese-speaking audiences. Twenty million subscribers from North, Central, and South America log on to StarMedia to access goods and services ranging from art, groceries, and books to computers, electronic equipment, and travel packages. At a time when content on the Internet is overwhelmingly in English, StarMedia offers Latin Americans a community experience combined with Spanish and Portuguese content, often tailored for regional dialects and local cultural norms.

Making a Channel Work

The biggest challenge in creating a shopping or auction channel on a service like StarMedia is that most, if not all, of the product offerings are provided on a co-branding basis with other partners. For subscribers, this means a high comfort level with the companies partnered with StarMedia. For the designer, it means creating a brand identity strong enough to stand alone but flexible enough to blend with the vendors' content.

Blending Brands

On both the shopping and auction StarMedia channels, vendor information is accessed through a frames environment where the StarMedia logo and navigation bar appear at the top of the screen. The remaining screen real estate consists of banner advertisements and vendor content. This standardized format helps users find their way around the whole StarMedia site.

To make sure the StarMedia frame integrates well with nearly 70 merchants, the designers chose a simple white background with bright primary-color accents. From this base, virtually any graphic design from a partner can be integrated with minimal modification. The clean color concept also reinforces the StarMedia brand in a world of flashing graphics and animated GIFs.

> **The clean primary-color concept reinforces the StarMedia brand in a world of flashing graphics and animated GIFs.**

StarMedia Shopping and Auctions Channels: StarMedia Networks, 29 W. 36th Street, 5th Floor, New York, NY 10018, (212) 548-9600

Executives: Tomas Melian, Vice President for E-Commerce; Betsy Scolnik, Senior Vice President of Business Development **Design Team:** Internal staff
Toolbox: Vignette, Photoshop

- **Website Objective:** To create an online shopping environment where users have faith in the StarMedia brand and trust the selected partners.
- **Creative Strategy:** Develop customer-focused shopping and auction channels that help online shoppers easily find the products and brands they are interested in. Create a brand that easily meshes with multiple co-branding opportunities.
- **Target Audience:** Twenty million Spanish- and Portuguese-speaking subscribers.

>> StarMedia's primary colors logo makes co-branding with vendors easier.

>> The standardized navigation bar is customized for location and language.

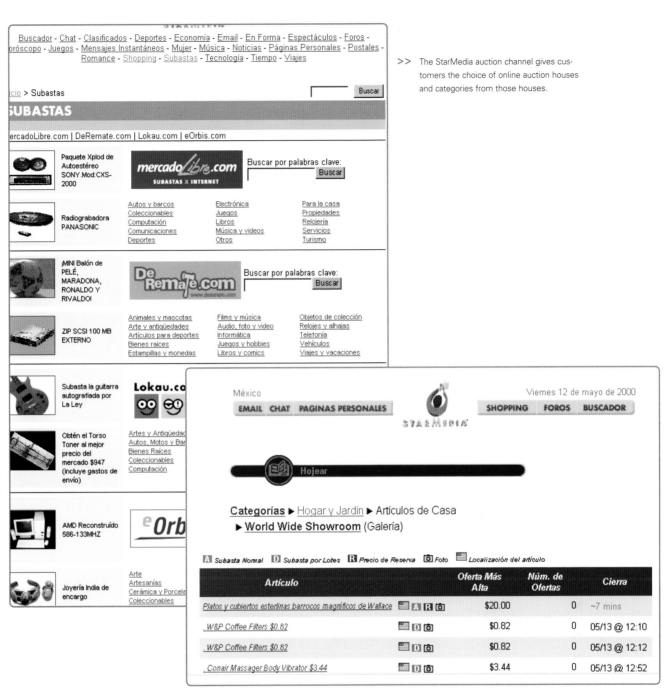

>> The StarMedia auction channel gives customers the choice of online auction houses and categories from those houses.

>> Once customers choose an auction house, items for bid appear in the standardized StarMedia frames window.

StarMedia is the leading global Internet media company for Spanish- and Portuguese-speaking audiences.

Fun is the keyword for bluefly.com.

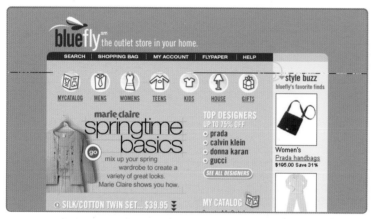

>> The home page sets the tone for a fun online shopping experience.

Discount Shopping Made Fun

- Customers want to enjoy the shopping experience.
- Give users different ways to sort through merchandise.
- Customers should be able to develop an accurate sense of the products through text and images.

10
bluefly.com

The Idea

A couple of years ago, bluefly.com CEO Ken Seiff spent a frustrating day outlet shopping, rummaging through disorganized bins of out-of-season designer clothing. He knew there must be a better way. Within a few months, he developed bluefly.com's core concept: an Internet-based lifestyle brand offering consumers top designer labels in a fun, friendly, smart, and stylish way.

Making It Fun

Fun is the keyword for bluefly.com. The site is filled with fun colors, icons, and eye candy features that go the extra mile to enhance users' shopping experience. The entire site maintains an attitude of amusement and accessibility, making it enjoyable to browse the content. A prime example is the top navigation bar, which brightens with a single added color when users roll over the menu with their cursor.

Because merchandise changes routinely in a discount shopping environment, the fun atmosphere of the site is balanced by a strong organizational architecture and an accurate search engine that allows users to search by product category, favorite designer, or price. Bluefly also offers the mycatalog feature, which creates an online personalized catalog based on the user's preferences and sizes.

Adding Value

Additional editorial content flows smoothly throughout the site in the form of helpful product and designer descriptions. Co-branded articles from fashion magazines about creating a designer wardrobe on a budget and a monthly online newsletter called *Flypaper* bring a smart, casual voice to the site and forge a feeling of trust with the customer.

The actual shopping experience at bluefly is a breeze. Large, clear images of the merchandise enable users to develop a sense of the product. The shopping bag details every aspect of the transaction, including a smaller image of the selected item, in a concise and simple format.

bluefly.com: 42 W. 39th Street, 9th Floor, New York, NY 10018, (212) 944-8000

Executives: Ken Seiff, CEO/Founder; Marty Keane, Vice President of Product Development **Design Team**: <kpe>, Kervin Ligasan – Art Director, Rik Catlow – Graphic Designer **Toolbox**: Adobe Illustrator, Photoshop and GoLive.

>> Cartoonlike icons enhance the copy and
guide users through the site.

>> Use of a single bright color enhances the
rollover feature on the navigation bar.

>> The *Flypaper* newsletter adds helpful fashion advice tailored to the
current product selection.

- **Website Objective:** To develop an Internet-based lifestyle brand offering consumers top designer brands in a fun, friendly, smart, and stylish way.
- **Creative Strategy:** To create and promote a fun attitude and style through innovative, high-quality products and services.Create a brand that easily meshes with multiple co-branding opportunities.
- **Target Audience:** 25–35-year-old women shopping online, perhaps for the first time.

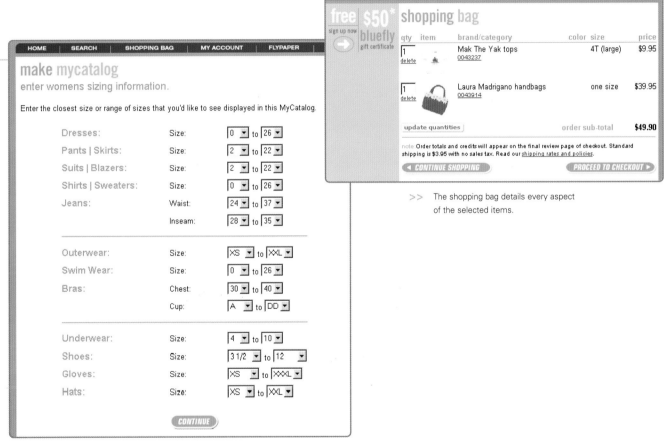

>> The shopping bag details every aspect of the selected items.

>> When setting up the mycatalog feature, customers can select a range of sizes.

>> Fast-moving specials are featured on the fly buys page.

>> A simple search engine interface allows users to search by category, price, or style number.

gifts

gifts / cosmetics
accessories

cosmetics accessories (all designers)

sorted by what's new! | re-sort by price page 1 2 ◉

SHOP BY:

price
color

designer ▾
browse cosmetics
accessories by designer...

▫ **all designers**
Donna Karan /
DKNY
Fina Firenze
Kerri Kahn
Laura Madrigano
Maria Turgeon
Mike + Ally
Temma Dahan

BROWSE...

gifts
- all designers
- all categories
- style buzz

TRENDS...

Father's Day Gift
Guide
Flybuys!

Laura Madrigano
$29.95 Save 38%

Laura Madrigano
$24.95 Save 49%

Laura Madrigano
$29.95 Save 45%

Fina Firenze
$29.95 Save 51%

Laura Madrigano
$24.95 Save 41%

Kerri Kahn
$29.95 Save 38%

Fina Firenze
$29.95 Save 51%

Kerri Kahn
$19.95 Save 59%

Kerri Kahn
$14.95 Save 65%

Kerri Kahn
$14.95 Save 65%

Kerri Kahn
$19.95 Save 61%

Donna Karan /
DKNY
$12.95 Save 54%

Donna Karan /
DKNY
$12.95 Save 54%

Temma Dahan
$24.95 Save 59%

>> Small, clear product images help customers make quick decisions.

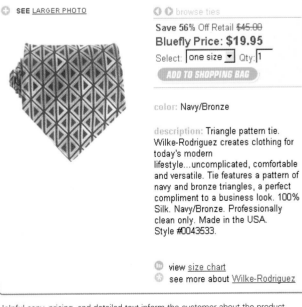

Wilke-Rodriguez ties

⊕ SEE LARGER PHOTO

◉ ◉ browse ties

Save 56% Off Retail $45.00
Bluefly Price: $19.95
Select: one size ▾ Qty: 1

(ADD TO SHOPPING BAG)

color: Navy/Bronze

description: Triangle pattern tie.
Wilke-Rodriguez creates clothing for
today's modern
lifestyle...uncomplicated, comfortable
and versatile. Tie features a pattern of
navy and bronze triangles, a perfect
compliment to a business look. 100%
Silk. Navy/Bronze. Professionally
clean only. Made in the USA.
Style #0043533.

🔟 view size chart
⊕ see more about Wilke-Rodriguez

>> Helpful copy, pricing, and detailed text inform the customer about the product.

Finance, Banking, and Business-to-Business Sites

>> Consumer and Retail Sites

>> Finance, Banking, and Business-to-Business Sites

Just as the business section of the newspaper portrays a different atmosphere than the lifestyle section, business-oriented websites look and feel different from their cyber-relatives in the consumer world. Most notably, business customers are in an even bigger rush than average consumers. For these people, time means money and time spent waiting for inaccurate information or out-of-date products is a complete waste. Many of the sites in this section don't bother with a fancy home page or video introduction. Technology like that is reserved for demos or additional features that can be accessed at users' convenience. As Vince Bohner, director of customer experience for NextCard, says, "Speed is of the essence."

Customers should enjoy using finance and business sites, though. A welcoming environment appeals to everyone, everywhere. Sites like the Motley Fool utilize bright colors and lighthearted copy to create a comfortable world in which investors can find the information they need. Mirroring the "work casual" corporate dress code that is becoming the norm, business-related websites may operate in a less formal environment, but they've still got to deliver the goods.

"The easier the site is to use and the more helpful feedback and information our customers can find, the higher our rate of retention. They have to find us valuable as well as easy to work with. We're creating an atmosphere of cooperation and collaboration," says Paul Smith, CEO of bSource.com.

>> Bright colors, lots of white space, and multiple navigation options welcome users to The Motley Fool home page.

Educate, Amuse, Enrich

- Don't be afraid to use bright color; it can be very effective.
- No one should struggle to get help. Make it easy for the user.
- Maximize the amount of white space on the page.

11
The Motley Fool

The Fool Attitude

It seems to be the nature of the beast that financial information is most often conveyed in dry, impenetrable text intended only for experienced investors and financial professionals. Not so at The Motley Fool. Every aspect of the Fool website is designed to be approachable and conversational. "The whole goal of copy throughout the site is to be very conversational and put users at ease, in order to help them make a good decision," says Keith Pelczarski, a longtime Fool employee. Graphic design elements reflect the same attitude: careful use of bright color, significant white space, and a focus on simplicity and breathability foster easy navigation.

The biggest challenge in tackling a site like the Fool lies in addressing an incredibly broad audience, from experienced professionals to novice investors. To accomplish this, search and QuickFind features and a "My Fool" customizable page satisfy the needs of the old pros. For the newbies, a special page appears when users visit the site for the first time, providing an overview of the information available and an optional tour of the site.

FoolMart

The same ability to serve a wide audience continues in FoolMart, the shopping area of The Motley Fool. Recommendations based on investment experience, the ability to get more information or buy a product immediately, and extensive customer service components ensure that every user's need is met.

FoolMart makes it as easy as possible to make a purchase. On every product page, users have multiple opportunities to order merchandise: once at the top left-hand part of the page when the product is introduced, and then again at the bottom of the page following the informational copy and details. The checkout process itself was the subject of intense focus during a recent redesign. "We did extensive usability testing, mental modeling, and walk-throughs," says Pelczarski. The result is a quick, almost effortless transaction.

The Motley Fool: 123 N. Pitt Street, Alexandria, VA 22314, (703) 838-3665

Executives: Brian Bauer, Chief Editor; Dwight Gibbs, Chief Technology Officer; David Forrest, Online Operations Manager; Jill Kianka, CEO, FoolMart
Design Team: Tracy Sigler, Jeb Bishop **Toolbox:** Photoshop, Ulead, HomeSite

16 17 18 19 20 21 22 23 24 25 26 27 28 29 30

>> First-time visitors are greeted with a brief overview of the site as well as the standard navigation options.

>> The FoolMart shopping area features approachable copy and the option to pursue more information or buy a product immediately.

- **Website Objective:** Educate, amuse, enrich. Help people make money.
- **Creative Strategy:** The Fool never actually had one, but the decision to make the design really clean was highly conscious.
- **Target Audience:** Anyone with a dollar in his pocket.

>> Compact presentation of product and price information accompanies every purchase opportunity.

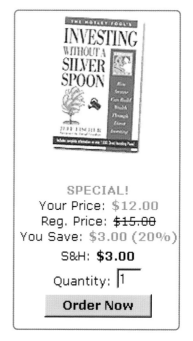

SPECIAL!
Your Price: $12.00
Reg. Price: $15.00
You Save: $3.00 (20%)

S&H: **$3.00**

Quantity: 1

Order Now

Unlimited Coverage - Company Reports

One year via e-mail (Acrobat PDF file)

Receive every report we produce on every company we cover for a charter price of $99! Yup, that's one year of <u>unlimited coverage</u> of our company research. Still unsure? Be sure to check our free <u>Amazon.com Report</u>!

>> Some Motley Fool products are available for delivery via e-mail.

>> The Fool toolbar provides navigation options to anywhere in the site.

A special page for newcomers appears when users visit the site for the first time.

FoolMart
The Motley Fool | Sitemap | Security

| Storefront | Books | Research | Software |

Storefront / Fun Stuff

Featured Fun Stuff

Jester Cap

No Fool should be without this velveteen jester's cap. Hand-made, this brightly-colored cap has real bells and comes one size fits all.

More Info | Buy It Now

>> Not every product in the FoolMart is specifically finance-related.

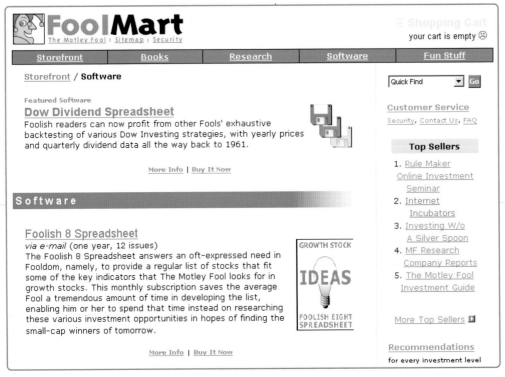

FoolMart
The Motley Fool | Sitemap | Security

Shopping Cart
your cart is empty ☹

| Storefront | Books | Research | Software | Fun Stuff |

Storefront / Software

Quick Find ▼ Go

Featured Software

Dow Dividend Spreadsheet

Foolish readers can now profit from other Fools' exhaustive backtesting of various Dow Investing strategies, with yearly prices and quarterly dividend data all the way back to 1961.

More Info | Buy It Now

Customer Service

Security, Contact Us, FAQ

Top Sellers

1. Rule Maker Online Investment Seminar
2. Internet Incubators
3. Investing W/o A Silver Spoon
4. MF Research Company Reports
5. The Motley Fool Investment Guide

More Top Sellers ▶

Software

Foolish 8 Spreadsheet

via e-mail (one year, 12 issues)

The Foolish 8 Spreadsheet answers an oft-expressed need in Fooldom, namely, to provide a regular list of stocks that fit some of the key indicators that The Motley Fool looks for in growth stocks. This monthly subscription saves the average Fool a tremendous amount of time in developing the list, enabling him or her to spend that time instead on researching these various investment opportunities in hopes of finding the small-cap winners of tomorrow.

GROWTH STOCK
IDEAS
FOOLISH EIGHT
SPREADSHEET

More Info | Buy It Now

Recommendations
for every investment level

>> Each area of the FoolMart details available products as well as the top sellers.

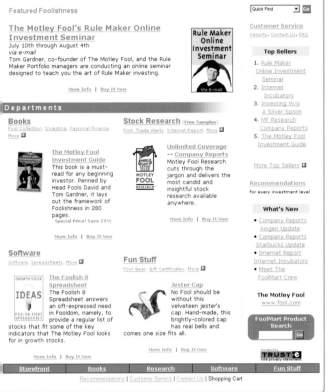

>> The FoolMart area of the site features all Motley Fool products for sale.

Trade Alerts: All Portfolios
via e-mail

Includes the Rule Breaker, Rule Maker, Drip, Boring, and Foolish Four Portfolios.

PLEASE NOTE: This is not a DAILY news e-mail service!! You will receive sporadic notifications dependent on trading decisions. In addition, we cannot guarantee your updates will arrive in your mailbox prior to the information being posted in our forum, but they should arrive at about the same time.

Your Price: **$25.00**

Quantity: 1

Order Now

If you follow any or all of the Motley Fool's Portfolios, you'll probably want to know when we make a trade in them. Well, in truly Foolish style, the Fool always announces trades in its portfolios prior to actually making those trades. Such announcements are readily available online in our Stock Strategies area. But what if you don't have time to check in with us every day? Or maybe you don't feel like searching for the portfolio reports each weeknight?

Introducing *Portfolio Trade Alerts*.

For only 25 bucks annually, we'll send you every one of our Foolish investment decisions via e-mail. While our trade announcements are also posted online at roughly the same time, you'll enjoy the convenience of not having to check in every day to find out what's happening in our portfolios.

When we announce an intention to trade, we will make that trade within the next WEEK. This policy should smooth out what have in the past been occasionally exaggerated moves in stocks the day we trade them. We've never wanted or liked that... and we gain no benefit from it. In fact, we get hosed just as anybody else would when the stocks jump or dive! Promising to trade within the next WEEK will give our portfolios the freedom to get a better price without being slave to the whims of market makers.

In addition to these trade notifications, you'll also receive an e-mail update from us about once a month letting you know whether or not there were any trades in any of the portfolios in the previous month. Will this be an awe-inspiring display of worldly unWisdom? Probably not... it'll be fairly rote. But regardless of how much or how little activity the portfolios experience, you'll always KNOW that you're still on our mailing list and that you haven't missed any trade announcements. Your Portfolio Trade Alerts subscription includes trades made in all active Motley Fool portfolios -- the Rule Breaker, Rule Maker, Drip, Boring, and Foolish Four.

You are on the mailing list within two business days of placing your order in FoolMart.

Check out the Product Review area to see what other Fools have to say about FoolMart products!

Quantity: 1

Your Price: **$25.00**

Order Now

>> The product page offers customers two opportunities to purchase products.

Every aspect of the Fool website is designed to be approachable and conversational.

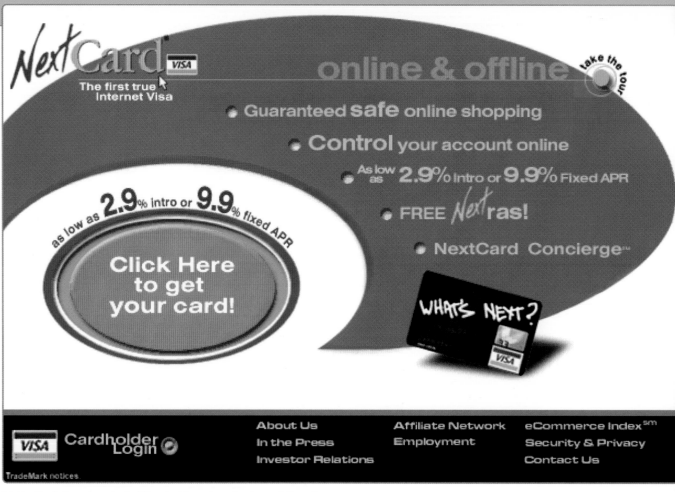

>> A bright, friendly home page clearly defines the information and options available to the user.

The First True Internet Visa

- Keep the approach as simple as possible.
- Manage when and how the customer receives information.
- Focus on the brand.

12
NextCard

If the basic concept behind the Internet is to make things easier, faster, and generally more convenient, the NextCard site wraps up all of those advantages and adds a few to boot. Every aspect of the site is well designed and easy for the customer to use, from the application process through the add-on features.

Making Decisions for the Customer

"Speed is of the essence," says Vince Bohner, director of customer experience for NextCard. "When we were designing the application process, we had to make decisions about what information we wanted customers to have and when. One of the things we decided to do was streamline the application process as much as possible. Once customers were approved, then we presented them with different rates and options."

The same judicious flow of information applies to the customer update interface. The basics of the statement are presented in a compact format, and more detailed information is no more than a click away. "We have to make it easy for users to know what to do once they get to a page. Too many options can be overwhelming," adds Bohner.

Keeping the Brand Intact

Since the NextCard site launched in December 1997, the scope of the site has changed tremendously. New credit card products have been added, functionality has been enhanced, and the content and company vision have evolved. In order to maintain ease of use, NextCard has focused on maintaining the brand image. All of the pieces of the site work together, thanks to the simple palette, trademark blue whorl, and NextCard logo. Amazingly, co-branded products still dovetail with the NextCard brand to create a unified presentation for users.

What's Next

As the company continues to grow, Bohner works hard to stay abreast of the latest technology, ensuring that his customers have access to the best the Internet has to offer. "I'm looking forward to a time when we have universal broadband Internet access and WYSIWYG tools that give business owners and designers more control over dynamic content," he says.

NextCard, Inc.: 595 Market Street, Suite 1800, San Francisco, CA 94105, (415) 836-9700

Executives: Jeremy Lent, President; Dan Springer, Chief Marketing Officer; Sue deLeeuw, Vice President, Brand **Design Team:** Vince Bohner, Deborah Harkins, Andrew Hargreaves, Zachary Lazare, Marci Singer **Toolbox:** Photoshop, Illustrator, GoLive, Image Ready, Macromedia Fireworks, Flash, DreamWeaver, BBEdit, HomeSite, QuarkXpress, Microsoft Office, ColdFusion, IView, HTML, ASP, JSP, ATC Dynamo

16 17 18 19 20 21 22 23 24 25 26 27 28 29 30

Congratulations! You're approved!

You're approved for the Standard NextCard Visa. Your excellent credit means you qualify for personalized upgrade packages. Click a card to choose your upgrade p

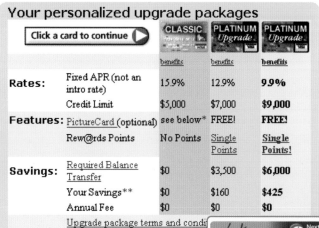

>> Simple presentation of credit card options helps potential customers make decisions.

>> A standard navigation bar with brand colors and design reinforces the NextCard image.

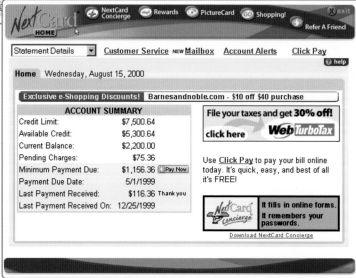

>> Account statement basics are combined with other offers without overwhelming the customer.

- **Website Objective:** Actually, NextCard has three: acquisition of new customers, creation of easy application experience, excellent customer management and retention.
- **Creative Strategy:** Make the NextCard experience as fast as possible.
- **Target Audience:** Internet users in general.

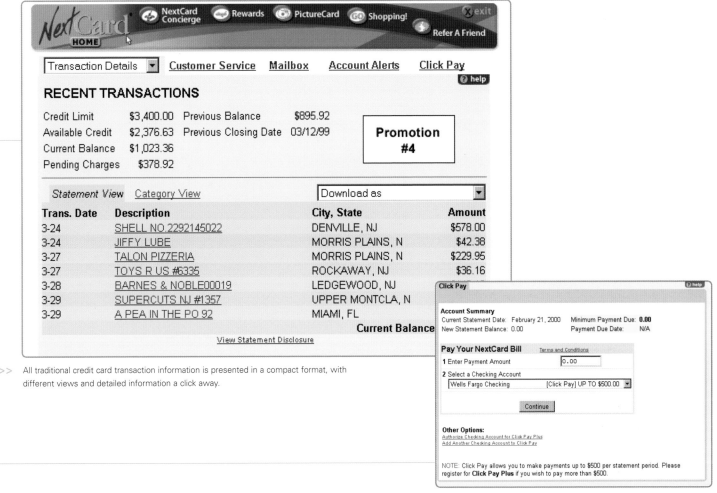

>> All traditional credit card transaction information is presented in a compact format, with different views and detailed information a click away.

>> All transactions are boiled down to the essentials, making them easy to understand and conduct.

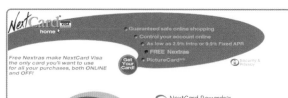

Free Nextras make NextCard Visa
the only card you'll want to use
for all your purchases, both ONLINE
and OFF!

• Guaranteed safe online shopping
• Control your account online
• As low as 2.9% Intro or 9.9% Fixed APR
• FREE Nextras
• PictureCard℠

Get Your Card!

Security & Privacy

>> NextCard features several
different bonus programs
for users.

"With our other credit
cards, it took us 12
months to get a free
airline ticket. With
NextCard Rewards,
it only took
6 months!"

NextCard Rewards℠
Rewards Points! Earn FREE flights
and merchandise just for using
your NextCard.

GoShopping!℠
Find the lowest prices anywhere
on the Web.

Concierge℠
Make purchases online with just 1
click!

Details

NextCard Rewards
Earn FREE flights and merchandise just for using your NextCard to make
purchases. Open an account with a qualifying balance transfer, and every $1
spend with your NextCard Visa can earn you Rewards Points to use for travel o
the airline of your choice, or for clothes, music, dining, books, and more! Visi
Rewards Page to learn more.

GoShopping!
GoShopping! puts the latest in online shopping technology at your
fingertips. Simply type in the company or product you're looking for and
GoShopping! does all the work. It will search the Web to find the lowest prices
and the highest consumer-rated online merchants for FREE. You can even get
personalized digital coupons from brand name stores delivered directly to you

Try GoShopping! for free right now.

Concierge
Ready to buy? Your NextCard Concierge makes shopping online a cinc
Your FREE Concierge remembers all of your passwords, logs you into websites
and automatically fills in online purchase forms with your shipping address an
your NextCard Visa account number with just 1 click. NextCard Concierge work
with all of the Top 100 online merchants and thousands more.

Download your free Concierge now.

Get Your Card!

Home |Guaranteed Safe Online Shopping| Contro
As low as 2.9% Intro or 9.9% Fixed APR | FREE N
About Us | Contact Us | Security & Privacy | Press

Details

NextCard Rewards
Earn FREE flights and merchandise just for using your NextCard to make
purchases. Open an account with a qualifying balance transfer, and every $1 you
spend with your NextCard Visa can earn you Rewards Points to use for travel on
the airline of your choice, or for clothes, music, dining, books, and more! Visit our
Rewards Page to learn more.

GoShopping!
GoShopping! puts the latest in online shopping technology at your
fingertips. Simply type in the company or product you're looking for and
GoShopping! does all the work. It will search the Web to find the lowest prices
and the highest consumer-rated online merchants for FREE. You can even get
personalized digital coupons from brand name stores delivered directly to you.

Try GoShopping! for free right now.

Concierge
Ready to buy? Your NextCard Concierge makes shopping online a cinch.
Your FREE Concierge remembers all of your passwords, logs you into websites,
and automatically fills in online purchase forms with your shipping address and
your NextCard Visa account number with just 1 click. NextCard Concierge works
with all of the Top 100 online merchants and thousands more.

Download your free Concierge now.

Top

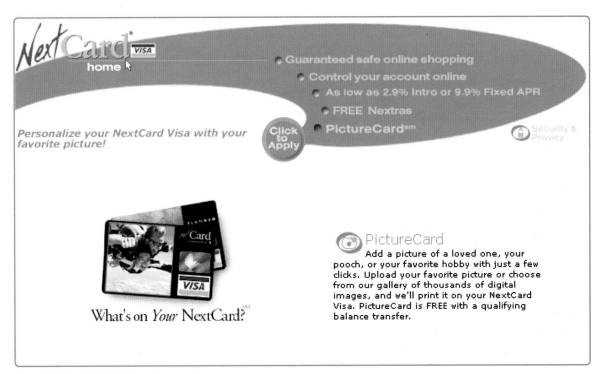

>> Customers can personalize their
NextCard with different images.

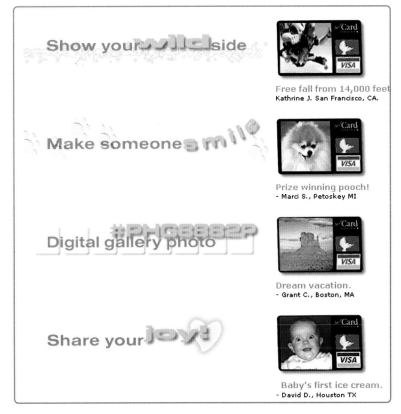

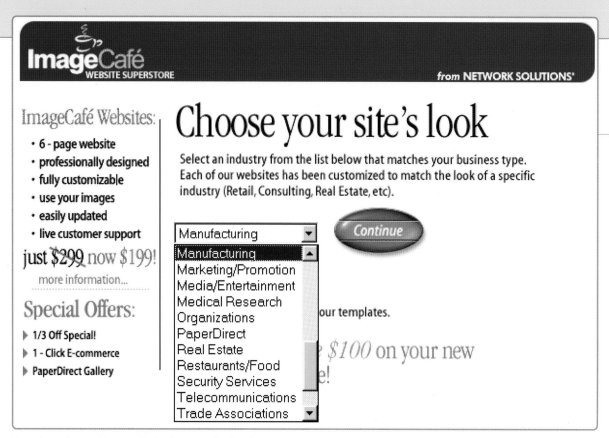

ImageCafé Websites:
- 6 - page website
- professionally designed
- fully customizable
- use your images
- easily updated
- live customer support

just $299 now $199!

more information...

Special Offers:
▶ 1/3 Off Special!
▶ 1 - Click E-commerce
▶ PaperDirect Gallery

ImageCafé WEBSITE SUPERSTORE

from **NETWORK SOLUTIONS**

Choose your site's look

Select an industry from the list below that matches your business type. Each of our websites has been customized to match the look of a specific industry (Retail, Consulting, Real Estate, etc.).

Manufacturing

| Manufacturing |
| Marketing/Promotion |
| Media/Entertainment |
| Medical Research |
| Organizations |
| PaperDirect |
| Real Estate |
| Restaurants/Food |
| Security Services |
| Telecommunications |
| Trade Associations |

Continue

our templates.

$100 on your new

>> Users choose from a wide range of industries to start the shopping process.

Putting Small Business Online Without a Big-Business Price tag

- Present a business-to-business product in a sophisticated and professional manner.
- Get the customer engaged and educated.
- Do as much of the hard work as possible for your customer.

13
ImageCafé

The Concept

The websites that get the most attention these days are the big guns: major corporations with massive budgets. What about the small-to medium-sized business owner who needs an online presence but doesn't have tens of thousands of dollars to spend on design? That's where Image Café comes in. A warehouse of customizable website designs and styles, Image Café's mission is to educate smaller businesses about the benefits and requirements of professionally designed websites.

"We want to draw customers into a friendly environment that holds their hand as they go through the purchasing process," says Dan Gilmartin, vice president of business development for Image Café. Instead of overwhelming customers with technical specifications and jargon, imagecafe.com creates a relaxed shopping environment, transforming a daunting task into something easy and even enjoyable.

How They Do It

The graphical user interface for ImageCafe is one of the easiest to use. Within minutes of entering the site, customers can "try on" different styles, images, and colors for their website. When using the website demo, customers experience the extraordinary proprietary engine that develops an image of the company name or slogan and inserts it into the website template—within seconds.

Once the customer signs up with ImageCafe, the ease of use continues. The Website Manager Control Center interface lists all the pages of the user's website pages, with easy-to-understand buttons for editing text, viewing the pages, importing images, and every other conceivable task,from publishing the site to accessing tools to help the user promote and market the website. Just in case, live online help is available seven days a week to answer questions.

"We believe the technology we've developed is the best out there," says Gilmartin. "The challenge is to invite the customer to come in and use it, to get them engaged and educated as to why we're the best. It has to be a welcoming environment."

ImageCafé Inc.: 5565 Sterrett Place, Suite 210, Columbia, MD 21044, (410) 997-3830

Executives: Clarence Wooten, VP of ImageCafé, Division of Network Solutions **Design Team:** Steven Mayton, Creative Director **Toolbox:** Photoshop, HTML, JavaScript, whatever offers the best tools for the task at hand

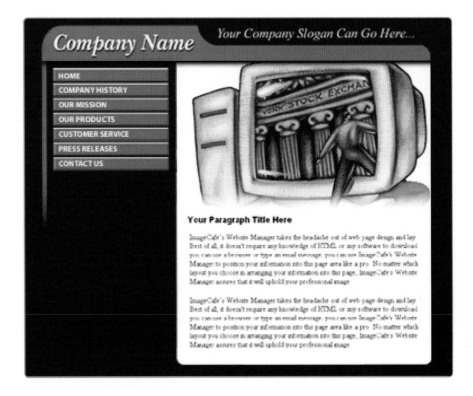

Color Scheme:

Choose your color scheme.

Ruby Red ▼

[Update View]

Image Motif:

Choose an Image Motif.

E/Exchange ▼

[Update View]

Note: When you add your content to your pages you will be able to upload your own logo for display within the page.

GO TO NEXT STEP

 LIVE SUPPORT

>> Choice of color and image motif allows customers to try different looks within a site.

- **Website Objective:** To educate small business customers about the benefits and requirements of professionally designed websites.
- **Creative Strategy:** Draw customers into a friendly environment that holds their hand as they go through the purchasing process.
- **Target Audience:** Small business owners.

Imagecafe.com creates a relaxed shopping environment, transforming a daunting task into something easy and even enjoyable.

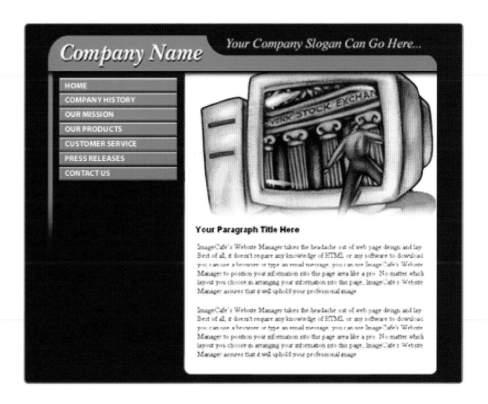

The graphical user interface for ImageCafe is one of the easiest to use.

>> By using the online demo, users can experiment with the site master setup and dynamic image generation engine.

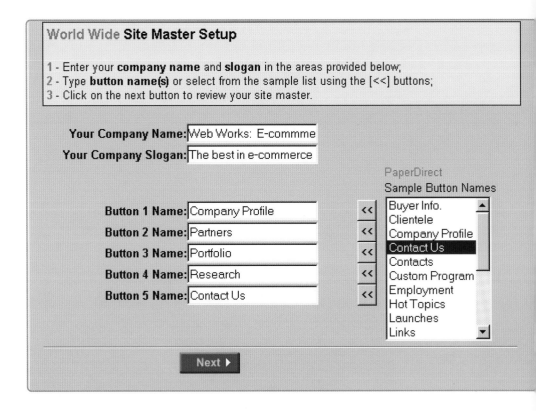

World Wide Site Master Setup

1 - Enter your **company name** and **slogan** in the areas provided below;
2 - Type **button name(s)** or select from the sample list using the [<<] buttons;
3 - Click on the next button to review your site master.

Your Company Name: Web Works: E-commme

Your Company Slogan: The best in e-commerce

PaperDirect
Sample Button Names

Button 1 Name: Company Profile <<
Button 2 Name: Partners <<
Button 3 Name: Portfolio <<
Button 4 Name: Research <<
Button 5 Name: Contact Us <<

Buyer Info.
Clientele
Company Profile
Contact Us
Contacts
Custom Program
Employment
Hot Topics
Launches
Links

Next ▶

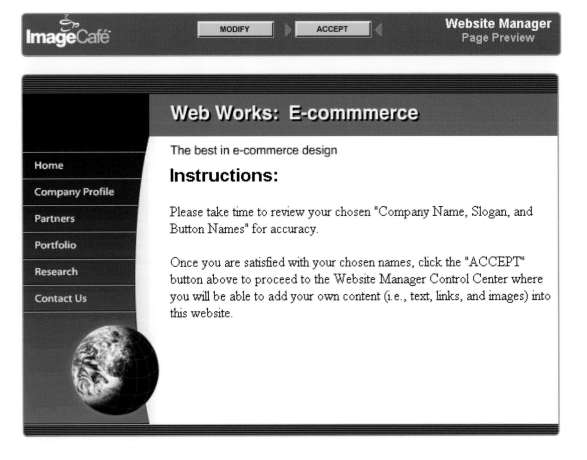

ImageCafé MODIFY ▶ ACCEPT ◀ **Website Manager**
Page Preview

Web Works: E-commmerce

Home
Company Profile
Partners
Portfolio
Research
Contact Us

The best in e-commerce design

Instructions:

Please take time to review your chosen "Company Name, Slogan, and Button Names" for accuracy.

Once you are satisfied with your chosen names, click the "ACCEPT" button above to proceed to the Website Manager Control Center where you will be able to add your own content (i.e., text, links, and images) into this website.

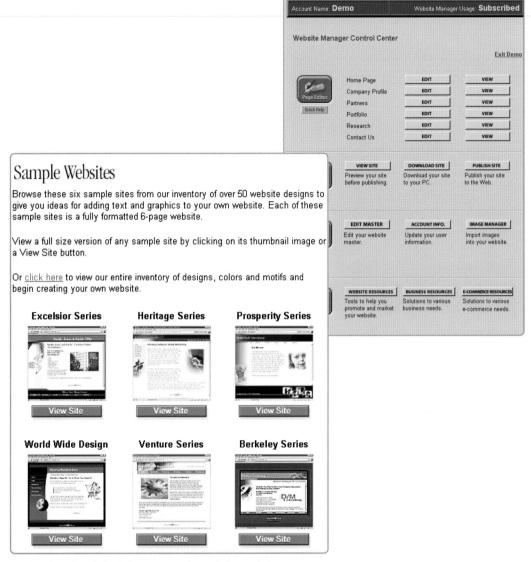

The Website Manager Control Center provides a quick and easy interface for updates and changes.

Sample Websites

Browse these six sample sites from our inventory of over 50 website designs to give you ideas for adding text and graphics to your own website. Each of these sample sites is a fully formatted 6-page website.

View a full size version of any sample site by clicking on its thumbnail image or a View Site button.

Or click here to view our entire inventory of designs, colors and motifs and begin creating your own website.

Excelsior Series

Heritage Series

Prosperity Series

World Wide Design

Venture Series

Berkeley Series

A series of sample websites helps customers choose the best website style for their needs.

We believe the technology we've developed is the best out there... the challenge is to invite the customer to come in and use it.

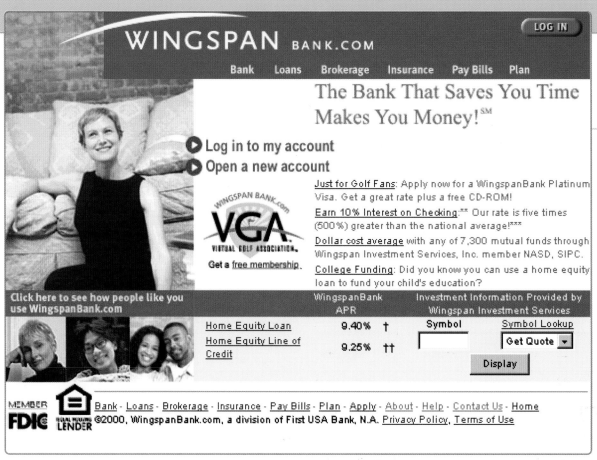

>> The WingspanBank home page sets the tone for the site: friendly technology.

The Original Online Bank and Financial Services Site

- Place the brand image foremost in the mind of the customer and designer.
- Account information doesn't need to be dressed up.
- Make important navigation options stand out visually.

14
WingspanBank.com

The Short Road to Success

Given the relatively short period of time online banking has been around, it's remarkable how quickly WingspanBank has established itself as the leader in online banking and financial services. Founded in 1999 to solve the frustrations many people experience when dealing with money issues, Wingspan enables customers to manage almost every aspect of their finances on one easy-to-use website.

The successful balance of technology and customer service as well as a direct appeal to a younger audience separates Wingspan from other online financial organizations. From the home page to account information, Wingspan delivers the advantages of high-technology banking with a personal approach.

Comprehensive Services, Consolidated Site

Perhaps the biggest challenge facing the Wingspan design team is trying to make such a wide variety of services feel personalized to the user. Customers have access to checking accounts, credit cards, insurance quotes, certificates of deposit, investment information, brokerage services, online bill payment, and financial planning tools, not to mention customer service. Still, throughout the site, the Wingspan brand remains strong, and navigation is a snap.

The Look

On the home page, black and white images of potential customers combined with the muted blue and white logo provide a contemporary look and feel. Important navigational points, like logging in and applying for an account, are highlighted in brighter shades of red and green. Deeper into the site, the logo/navigational bar maintains the brand image while stylized icons highlight product offerings. Account information and applications are pared to the bare minimum of graphic features, utilizing color bars and text only where they enhance the organization of the information presented on the screen.

> **Black and white images of potential customers combined with the muted blue and white logo provide a contemporary look and feel.**

WingspanBank.com: 201 North Walnut Street, Wilmington, DE 19801

Executives: Michael Cleary, CEO; Bill Wallace, CIO; Kevin Waters, Senior Vice President, Marketing; Chris Sulpizio, Senior Vice President, Operations; Chip Weldon, Senior Vice President, Interface Engineering **Design Team:** Mike Young, Information Architect; Patty Kingery, Vice President, Production **Toolbox:** Frames, HTML, Adobe Photoshop, Checkfree servers, Pershing servers

Throughout the site, the Wingspan brand remains strong and navigation is a snap.

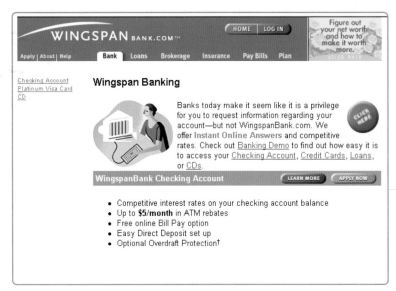

>> Detailed information about services is presented in a user-friendly format.

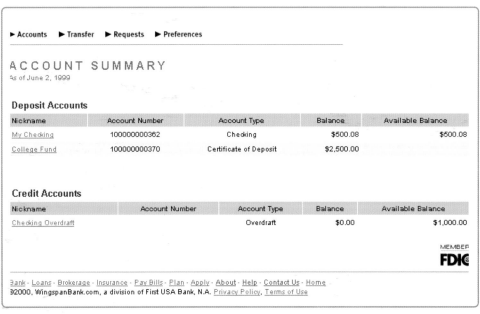

>> Account balances and related data are clearly organized.

- **Website Objective:** To help individuals maximize their financial potential on the web.
- **Creative Strategy:** Make Wingspan simpler and easier to use than the majority of financial websites currently available.
- **Target Audience:** Women, 25–45, in charge of family finances.

>> Financial planning tools support Wingspan's offerings.

>> A simple initial application filter customizes the application form to users' requests.

Application Center

Step 1
Check the box beside each desired product. Online responses in just 60 seconds.**

☐ Checking

☐ Bill Pay

☐ CDs

☐ Credit Card

☐ Brokerage-Individual ▼

Note: Printer recommended for brokerage.

Step 2
Select the "Apply" button. **Note:** Check all desired products before selecting the "Apply" button to ensure that we pull only one credit report.†

[Apply]

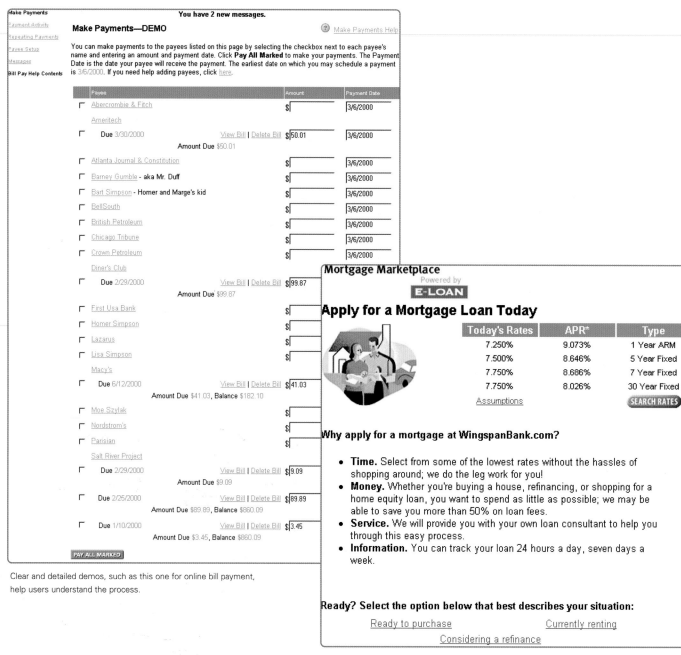

>> Clear and detailed demos, such as this one for online bill payment, help users understand the process.

>> Daily updates on mortgage rates and easy-to-understand text encourage users to utilize the Mortgage Marketplace.

Insurance Center

Welcome to The Wingspan Insurance Center.
Here you can compare free, no obligation quotes from some of the most trusted names in insurance. Simply fill out a profile—compare quotes—and choose the quote that's best for you.

Auto Insurance
Think you're paying too much for car insurance? Compare free quotes and see if you can save.

Homeowners Insurance
Owning or planning to buy a home? Get home insurance quotes right from your computer.

Renters Insurance
Need to protect your valuables? Get fast and free renters insurance quotes now.

Life Insurance
Thinking of getting life insurance? Get life insurance quotes with one easy-to-use form.

Health Insurance
Compare individual health insurance quotes f

Important Customer Information: Insuran underwritten by Wingspan Bank, or any of its affiliat FDIC insured, and are not a condition to a INSURANCE PRODUCTS ARE NOT AVAIL

>> Customers can compare insurance quotes on anything from renters insurance to health coverage.

WINGSPAN INVESTMENT SERVICES, INC. Member NASD/SIPC

▶ Trading Demo ▶ Portfolio Demo ▶ Research ▶ Marketwatch ▶ Quotes & News ▶ Customer Services

Brokerage

WIS Offers Dollar Cost Averaging! Systematically invest in any of 7,300 mutual funds!
FundProfiler! Use our high-tech tool to match funds to specific investment priorities.
Extended Trading Hours! Trade with us 8 a.m. to 7 p.m. Eastern time.
Trade for as little as $14.95! Check out our low fees.

Simple and Convenient Investing LEARN MORE APPLY NOW

Select from:
Quote - Stock (delayed) ▼

Enter Symbol:
[] Display

Find Symbol

>> Wingspan Investment Services provide the key elements for simple and convenient online investing.

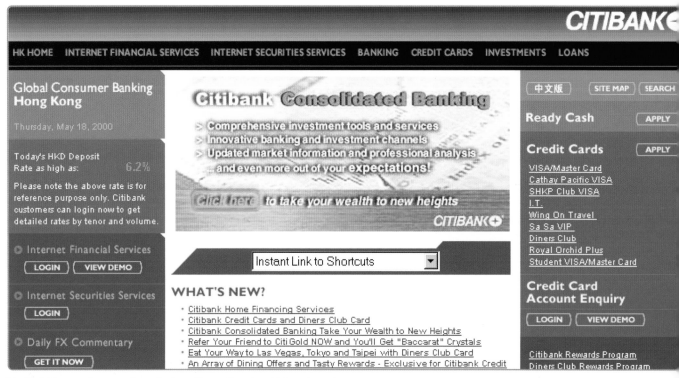

>> The English-language home page immediately provides a wide variety of information to the user.

Communicating a Global Brand to Two Different Cultures

- Understand the cultural and technological differences in your audience segments.
- Adopt corporate guidelines that do not limit creativity.
- Pace the environment to the customer.

15
Citibank Hong Kong

The Citibank Approach

Around the world, Citibank websites look very similar. Corporate image standards are issued to every country and business organization outlining fonts, colors, required text and links, and other brand-related provisions. Locally, country organizations and business groups develop and create their own sites within these corporate guidelines. Once refined, sites are transferred to a central staging location, where a technical and visual evaluation takes place. When the inevitable bugs and tweaks are taken care of, the sites are hosted and updated via a central location.

The Hong Kong Challenge

Three years ago, Hong Kong was a primarily English-speaking global business center. Since the Chinese government took over, the island has retained its prestige as an international commerce hub, while also representing an entire Chinese-speaking region. Creating a banking site to address these changes and the associated diverse audience provides an unusual challenge.

How Citibank Does It

Customers accessing the primary site at citibank.com.hk see the English-language site first. Packed with financial information, promotions for Internet-based services, credit card applications, and Citibank Hong Kong news, the home page provides a complete picture of the services available to Citibank customers.

When users access the Chinese-language site at citibank.com.hk/chinese, a much simpler interface is displayed. Instead of high volumes of information stuffed into a 640 x 480 screen, a more formal image offers a welcoming statement and links to various services. When investigating the credit card application process, users view three pages of text before being linked to an online application in English—the same one accessed through the English site.

The two Citibank Hong Kong sites reflect the differences in the two cultures of the customer base as well as the relative novelty of the Internet to most of the Chinese population. The English site furnishes as much information as possible as quickly as possible. The Chinese site follows a methodical protocol, carefully educating and directing the user through the sites.

Citibank Hong Kong: Global Consumer Banking, 9/F Dorset House, 979 Kings Road, Quarry Bay, Hong Kong , 852 2860 0333

Executives: Internal Internet Steering Committee **Design Team:** In house **Toolbox:** Netscape Enterprise Server

- **Website Objective:** To accurately convey the offerings of Citibank Hong Kong to both English- and Chinese-speaking audiences.
- **Creative Strategy:** Develop two sister sites that address the different needs and cultures of Citibank Hong Kong customers.
- **Target Audience:** Internet-savvy users in Hong Kong.

>> A welcoming statement and links to other areas of the site are the only content on the Chinese-language home page.

>> The top-level navigation bar on the Chinese site closely mirrors its English counterpart.

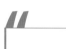

| HK HOME | 主網頁 | 理財服務 | 信用咭 | 投資 | 貸款 | 保險 | 最新推介 |

香港

環球個人銀行服務

連接 Citibank 網上
理財服務

連接 Citibank 網上
證券服務

網上申請銀行服務

Citibank「萬分回享」
積分計劃

「大來積分享精萃」目錄

理財服務

½Ð §Y ¥Ï 10 ¤À ÄÁ ®É ¶¡ ¡A ¤F ¸Ñ §Ú Ì ³º »È ¦æ ªA °È ¦p ¦ó ¥i °¡ ¬ ±z ³º Ó ¤H ²z °]ﾍ n ¨D ¡A Ó ÅU ±z ¤H ¥Ï ¤¤ ¨C Ó ¤£ ¦P ¥Ø ¼Ð ¡A ¨Ã ¥Ø ±z ³º °] I ¥R °¡ ¬¡ ¤¤ ¡A ¤£ Â_ ¼W ª ¡C

- ¡y ³Ì 'f ±z ¡z »È ¦æ ªA °È §©À
- CitiGold ¶Q »« »È ¦æ ªA °È
- ¤¡ ±M ¥Ï Åv ¯q - Citibank Student Banking Services

¡! ¥¬¡A n §Ö ¤H ¤@ ̈B 'x ¤ ²{ ¥N Ó ¤H ²z °] ¤§ ¹D ¡A ¨N n ²v ¥ý Ï ¥Í_U °é Ä_ ³q »È ¦æ ¥þ 'á ³Ð ¤¤ ¤¤ ¤¤ ¤W ²z °] ªA °È ¡I ¶Q ¬ §Ú Ì ¤« »È ¤á ¡A ±z ³º ¶ ¡· ¡¡ ²z ¥ô ¦ó ¤á Å¿ ¤¤ ¤¤ ¥Ï ¤n ³s ³s ±ü ¹³ Ã¤ ¤ ¶ ¡A ̈ «ö ¤¡ ±z ³º iv U³¤ ¡ii z ¹ ½X ¤¡¹ ¹q Ü ²z

>> Few promotional images are found on the
Chinese site, which is mostly text-driven.

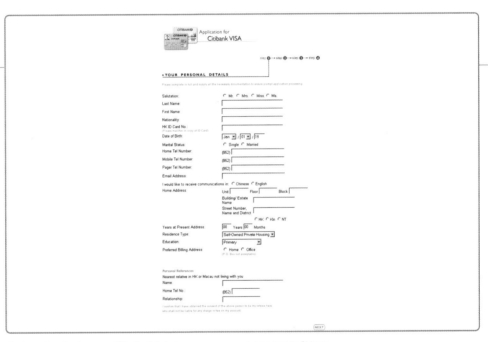

>> Credit card applications are still in English, but users may request responses in Chinese.

**When users access the Chinese-language site at citibank.com.hk/chinese,
a much simpler interface is displayed.**

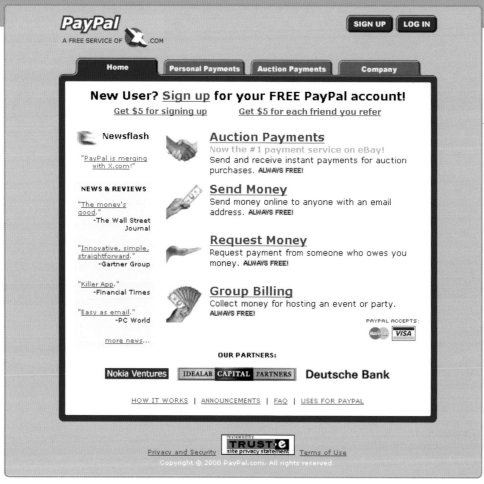

>> The PayPal home page outlines the uses of the service simply and effectively.

Secure Money Transfer to Any E-Mail Address in the United States

- Clear copy is essential in communicating a difficult concept.
- Look at site design as an ongoing process; both technology and users will grow and evolve.
- Take time to reassure users of security and privacy.

16
PayPal

Conveying the Concept

Sometimes it's difficult to convey an electronic commerce concept in a primarily visual environment. PayPal.com, an application that allows users to securely send money to any e-mail user in the United States, faces that problem daily. "When I verbally explain the PayPal concept to people, their response is usually enthusiastic," says Matt Bogumill, vice president of business development for X.com. "Portraying that idea clearly on the website has been an ongoing challenge."

The basic PayPal transaction looks like this: Bob owes Ann $50. Bob logs on to PayPal and registers. He then sends Ann $50 by entering his credit card information, her e-mail address, and the amount. Bob's credit card is charged $50, and a new account in Ann's name is created and credited with the money. Ann receives an e-mail notification that Bob has paid her, which includes a link to her account at PayPal. Ann registers her name and address with PayPal and can then withdraw her $50 by direct deposit to her bank or by a personal check from PayPal.

Other transactions include using PayPal to administer payments to online auction houses and disseminating group bills, such as for a fund-raiser.

What Customers Want

Because many Internet users remain wary of divulging credit card information online, much of the text in the PayPal site is devoted to assuring customers of security and privacy. PayPal decided against a graphics-heavy interface in favor of one based on simple tabs, a few basic graphics, and lots of helpful, explanatory text. It's not flashy, but it really works. "We're still in an educational phase with our customers," says Bogumill. "When we get to the point where people are familiar with the concept and more comfortable with online credit card transactions in general, we'll probably update our look and feel."

X.com: P.O. Box 50185, Palo Alto, CA 94303, (877) 6-PayPal

Executives: Max Levchin, Chief Technology Officer; Matt Bogumill, Vice President of Business Development Design Team: Luke Nosek, Vice President of Marketing; David Sacks, Vice President of Product Marketing Toolbox: HTML, Adobe Illustrator, Adobe Photoshop

16

PayPal
A FREE SERVICE OF X.COM

LOG IN

Home | Personal Payments | Auction Payments | Company

Secure Application 🔒

Quick 1-Page Registration

FIRST NAME:

LAST NAME:

STREET:

CITY: **STATE:** **ZIP:**

COUNTRY:
USA (PayPal is currently available to U.S. residents only.)

DAY PHONE: **EVENING PHONE** (optional):

Your email address will be used to log in to your PayPal account.
EMAIL ADDRESS: **RETYPE EMAIL ADDRESS:**

Password is case sensitive and must be at least 8 characters.
PASSWORD: **RETYPE PASSWORD:**

Please enter a question to which only you know the answer.
If you forget your password, this will be used to allow you to recover it.
Your answer must contain at least 2 words.
QUESTION: **ANSWER (2 words or more):**

Email address of the person who referred you (optional):

☐ Check here to indicate that you have read and agree to the Terms of Use.

☐ Check here if you do not wish to be notified of new products and services or custom... surveys.

Problems Signing Up?

Privacy and Security | FAQ | Terms of Use
Copyright © 2000 PayPal.com. All rights reserved.

>> A simple registration form helps ease user anxiety about the technology.

PayPal
A FREE SERVICE OF X.COM

SIGN UP LOG IN

Home | Personal Payments | Auction Payments | Company

Overview | Why Use PayPal | How it Works | Withdrawing Money | Logo

Overview

SIGN UP TODAY!
CLICK HERE

PayPal makes your auction payments quicker, easier and more secure than ever before. Buyers can now make instant payments and sellers can now accept payments from anyone with a credit card. Best of all, the service is completely **FREE.**

AUCTION SELLERS

- Buyers pay with MasterCard VISA
- Receive money instantly
- Use on any auction site
- Get $5 just for signing up and $5 for each buyer you refer

ALWAYS FAST, FREE AND SECURE

AUCTION BUYERS

- Pay with MasterCard VISA
- Receive your purchase faster
- Protects your privacy
- Get $5 just for signing up and $5 for each friend you refer

ALWAYS FAST, FREE AND SECURE

SELLERS - Place a PayPal.com logo in your auction listings and receive $5 for every buyer you refer to PayPal.

Privacy and Security | FAQ | Terms of Use
Copyright © 2000 PayPal.com. All rights reserved.

>> A clear, concise overview of using PayPal
for online auction payments educates both
buyers and sellers quickly.

" **Much of the text in the PayPal site is devoted to assuring customers of**

security and privacy. "

- **Website Objective:** Develop a website to educate customers about the advantages and security of using the PayPal service.
- **Creative Strategy:** Maintain a simple interface with appropriate information and easy registration for the service.
- **Target Audience:** Anyone who is owed money and has an e-mail account.

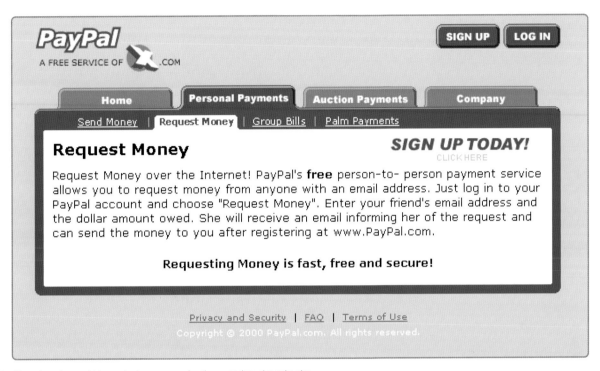

>> The color scheme of blue and pale green remains the same throughout the site.

>> Four main tabs remain in the same order throughout the site, with subcategories appearing once a tab is clicked by the user.

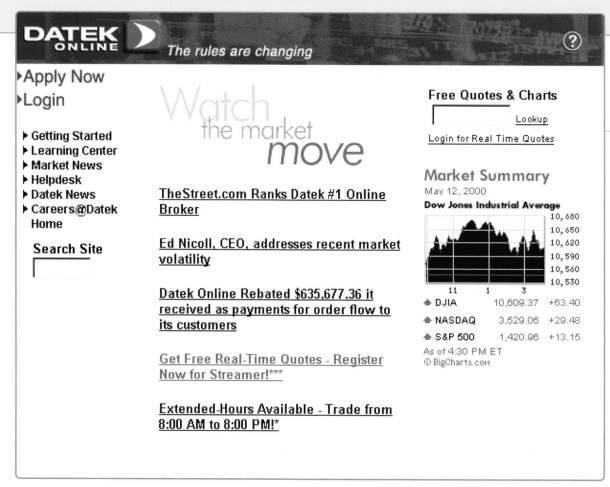

The pared-down home page lets users focus on the information they need.

The Rules Are Changing

- Take the time to make sure customers can understand the technology.
- Unify a technologically complex site with simple graphic elements.
- Let users customize their experience.

17
Datek Online

The Big Thing Now

Judging by sheer advertising volume, one might assume that the entire country is investing online, but a cursory survey of online brokerages leaves the inexperienced investor at a loss. Opening an account, placing a trade, monitoring the market, doing research—how does an individual choose one online brokerage over another? Presumably, all brokerages do essentially the same thing. Datek Online distinguishes itself from the rest of the pack with three significant features: friendly demos, step-by-step instructions on opening an account and a quick, intuitive interface. This combination of elements enables Datek both to boast high usability and to guarantee the execution of marketable orders within 60 seconds.

Maintaining Simplicity

The most notable aspect of the graphic design of the site is the signature green banner that appears at the top of every screen. The rest of the screen features blue or black text, small graphs and diagrams, and plenty of white space. Text written in plain English guides users through the site; instead of becoming overwhelmed with financial jargon, users gather relevant knowledge of the online trading process through surfing the Datek pages. Customer support is available around the clock.

Once customers have perused the site, setting up an account is straightforward. Clean and uncomplicated forms broken into seven understandable steps direct the user through the process. At every turn, customers are assured of the safety and security of the Datek site and technology.

Making Sense of Streamer

Datek's Streamer technology allows clients to view the movement of the market in real time, much as traders do on the market floor. The site designers took extra pains to make sure that the Streamer interface is understandable and usable for every customer. This approach starts with a comprehensive FAQ (frequently asked questions) section when the software is accessed and continues through buttons, allowing users to customize everything from stock lists to color palettes to font size.

"**Text written in plain English guides users through the site.**"

Datek Online: 100 Wood Avenue South, Iselin, NJ 08830-2716, (732) 516-8340

Executives: John Grifonetti, President and Chief Operating Officer; Peter Stern, Chief Technology Officer; Robert Bethge, Chief Marketing Officer
Design Team: Internal staff **Toolbox:** Proprietary software, HTML

- **Website Objective:** To enable investors to obtain the best possible trading experience.
- **Creative Strategy:** Provide an easy-to-navigate site that enables customers to rapidly access relevant information and then act on it.
- **Target Audience:** Internet-savvy, self-directed investors.

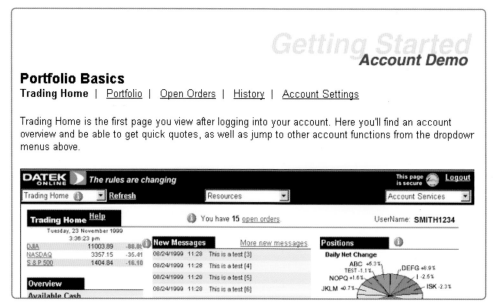

Real views of the interface and jargon-free text help first-time users understand the Datek system.

The signature green Datek banner appears at the top of every screen.

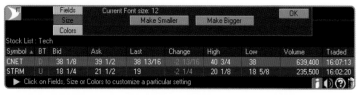

The Streamer interface is compact and easily customized.

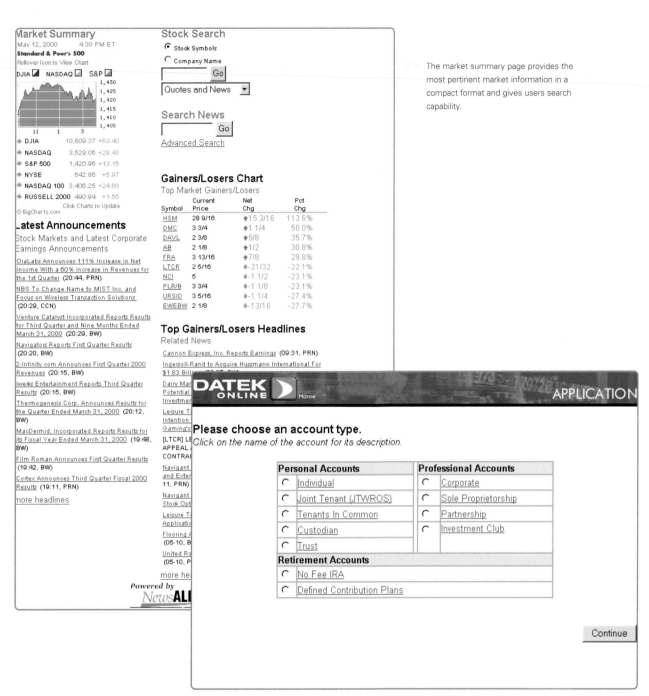

The market summary page provides the most pertinent market information in a compact format and gives users search capability.

Creating an account is a smooth process, thanks to a spare registration interface.

At every turn, customers are assured of the safety and security of the Datek site and technology.

chapter 3

>> Consumer and Retail Sites

>> Finance, Banking, and Business-to-Business Sites

Extranets and Subscription-Based Sites

What is an extranet? An extranet is a secure area of a website used to exchange information with business partners or customers. An extranet affords companies the ability to supply important information on a timely basis to the right people.

Dell's support site (support.dell.com, p. 138) provides valuable information to Dell computer owners, including software updates, tutorials, and order status. For Dell, the support site means deploying fewer human resources in the customer support area while providing the best customer support in the industry. For Dell customers, the support site means not having to wait on hold for the next available customer service agent.

Subscription-based sites form an interesting area of extranet development. While subscribers do not necessarily view proprietary company information, they do receive valuable services. These can range from technical support to editorial content to order status infor-

Intranet and Extranet Sites

mation. To retain that value, the company providing the subscription must ensure that only people or companies who have paid for the service can access it.

For 111 years *The Wall Street Journal* (p. 118) has provided highly respected business news. Now the *Journal's* website offers subscribers the same editorial content, plus additional online features. The success of the online version relies not only on its content but also on the communication of the *Journal's* reputation for excellence through the design of the site. As Jennifer Edson, executive director of design and product development, says, "Our design captures the essence of *The Wall Street Journal*, which brings with the brand the authority and reputation of the paper and the integrity of the journalism *The Wall Street Journal* is known for."

Your guidance team.

Welcome to the EdFinder.com. We assist professionals and families in making the best educational choices for children with special needs. The site contains a comprehensive database of private schools and special programs. If you are a current subscriber, login at right.

LOGIN:

Login

For Parents

Search Edfinder.com Database
Our database contains hundreds Of programs that may be right for Your child. Use our special search Wizard to find the best program.

Find an Expert
Once you find the program, let Edfinder.com connect you with an Expert to help you interpret the Results of the search, and to add Value to your decision making Process.

For Professionals

Search Edfinder.com Database
Our database contains hundreds Of programs that may be right for Your client. Use our special search Wizard to find the best program.

Professional Resources
Edfinder.com has assembled a wealth Of special resources specifically for educational consulting professionals.

>> The home page allows users to log in immediately or find out more about the site.

Helping Parents and Educators
Make the Best Decisions for Children

- Keep the interface simple.
- Provide only relevant options on the top level.
- Make the commerce component almost transparent.

18
EdFinder.com

The Concept

Today's parents find themselves overwhelmed with information about educational options for their children. EdFinder provides a portal for parents to easily filter information from literally hundreds of thousands of schools, colleges, summer camps, medical and therapeutic providers, and educational consultants and resources. Beyond offering this access to information, EdFinder also matches parents with experts who can help them make informed choices according to their child's specific needs.

Making It Work

The almost-Spartan graphic interface for EdFinder belies an incredibly complex multidimensional database, and in this lies its beauty. Rather than being overwhelmed by options right off the bat, parents or educators input a set of criteria specific to a particular child's needs. The result is a list of relevant programs for that child.

The E-Commerce Components

For a small fee, parents are matched with an expert who walks them through the identified options and assists them in making the best choice among them. Users can choose either short- or long-term commitments with the expert. Users and experts are connected through a central telephone system that tracks each individual call and stores it in a transaction database for billing purposes.

Professional users, like guidance counselors and librarians, pay an annual subscription fee for access to the database. Schools, camps, and other providers also are charged a fee to self-maintain their individual records in the database.

"This state-of-the-art application is completely Internet-based." says Damon Myers, president of xalient.com, the design firm responsible for pulling the project together. "EdFinder takes an intimidating if not completely overwhelming marketplace and makes it manageable for both parents and experts." This manageability, conveyed through an incredibly simple interface, makes EdFinder successful.

This state-of-the-art application is completely Internet-based.

EdFinder.com: 337 Summer Street, Boston, MA 02210, (800) 252-7910

Executives: Ben Mason, President and CEO; William Cole, Vice President and COO **Design Team:** xalient.com **Toolbox:** E-Business Application: Oracle8I, Java PL-SQL, CyberCash **Digital Telephony Switch:** MS- SQL 7.0, VisualBasic, VisualBasic Script

17 18 19 20 21 22 23 24 25 26 27 28 29 30

- **Website Objective:** To supply highly specific educational consulting information to parents in a central information database.
- **Creative Strategy:** Create an interface that reaches out to three distinct audiences without confusing any of them.
- **Target Audience:** Parents with annual income in excess of $85,000, education consultants, and guidance counselors.

edfinder.com
Your guidance team.

Thank You!

Your registration has been accepted. Now, enter the additional informat requested below. Once you submit this information, a list of experts will provided online and via email.

These experts will contact you within the next 24 hours, or you may ca directly using the 800 number and extensions provided.

Our child is a: ○ Boy ○ Girl

Our child's age is: []

Our primary concern is our child's: (check all that apply)

- ☐ Change in peer group
- ☐ Declining academic performance
- ☐ Defiance, rebellion against authority
- ☐ Drug and alcohol involvement
- ☐ Self-destructuive tendencies

\>\> The find-an-expert page starts with the most basic information and the most often requested categories.

>> As users drill deeper into the database, more specific information can be accessed.

>> The results page gives the users a list of relevant experts based on the input criteria.

The almost-Spartan graphic interface for EdFinder belies an incredibly complex multidimensional database.

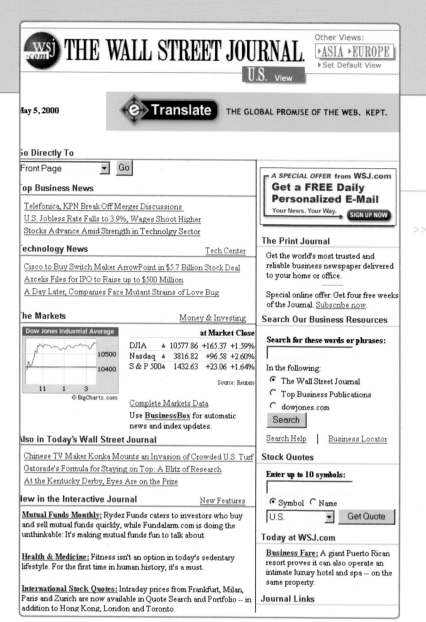

>> The home page brings all of *The Wall Street Journal's* best features to the forefront.

The World's Leading Source of Business and Financial News and Information

- Keep the user in mind at all times.
- Don't compromise the quality of the information.
- Integrate new technology judiciously.

19

The Wall Street Journal
Interactive Edition

Bringing a Legend Online

The interactive edition of *The Wall Street Journal* brings the reputation and integrity of one of the world's most respected newspapers online: a daunting task at best. In typical *Journal* style, the interactive edition clears the hurdle with room to spare, actually improving on the usability of the paper and leveraging the brand to include channels on careers, personal technology, startups, and more.

Easing the Transition

Logging on to wsj.com leads to a familiar experience. The format is essentially in black and white and retains the hallmarks of the print newspaper, such as the dot drawings, the logo, and the typeface in the sections.

"When we first designed The Wall Street Journal Interactive Edition, very few commercial sites were on the web. We needed to educate the world on what an electronic newspaper could be, how one from *The Wall Street Journal* would function and what it would look like," says Jennifer Edson, executive director of design and product development. "The visual identity is a clean, elegant, refined, and newsworthy design that reflects an unparalleled level of trustworthiness that readers expect from *The Wall Street Journal.*"

Making It Work

The advantages to subscribing to *The Wall Street Journal* online are readily apparent: immediate access to the European and Asian editions, complete search capabilities, and customization features deliver the best of the paper to users' fingertips. Headlines and links to the day's top stories and navigation to other areas of the site are packed onto the screen, but without appearing distracting or overwhelming. The site is continually updated, more often than once an hour, keeping the news fresh.

Keeping Pace with the Interactive World

"We are constantly challenged by the rapidly developing pace of the web environment," adds Edson. Future enhancements under consideration include adding a fourth column to utilize the additional space made available by high-resolution monitors, distributing content to personal digital assistants such as Palm Pilots, and integrating video, sound, and moving imagery.

The advantages to subscribing to *The Wall Street Journal* online are readily apparent.

The Wall Street Journal Interactive Edition: Dow Jones & Company, 200 Liberty Street, New York, NY 10281, (212) 416-2900

Executives: Neil Budde, Editor and Publisher, WSJ.com; Gordon Crovitz, Senior Vice President, Electronic Publishing, Dow Jones & Company **Design Team:** Jennifer Edson, Executive Director of Design and Product Development; Andrew Gianelli, Design Director **Toolbox:** Photoshop, Illustrator, Microsoft Excel, Deltagraph, DreamWeaver, Flash, Shockwave

- **Website Objective:** To be online what *The Wall Street Journal* is in print: the leading source of business and financial news and information.
- **Creative Strategy:** To capture a classic tone that appears timeless and preserves the integrity of *The Wall Street Journal*.
- **Target Audience:** High-end educated business professionals.

The page you requested is available only to subscribers.

If you're a subscriber...

Please enter:

User Name: [＿＿＿＿＿＿＿＿＿]

Password: [＿＿＿＿＿＿＿＿＿]

[Sign On]

Forgot your User Name or Password?

☐ Save my User Name and Password
More information about this feature

If you're new...

- Learn more about subscribing to The Wall Street Journal Interactive Edition and Barron's Online.

- Register now as a NEW subscriber.

- Read our Privacy Policy.

>> The login page is free of extraneous graphics and features, speeding the user to more information.

>> Careful use of color enhances the signature black-and-white color scheme, helping appropriate sections stand out.

>> The top-level banner features date, time, up-to-date market information, and search capabilities.

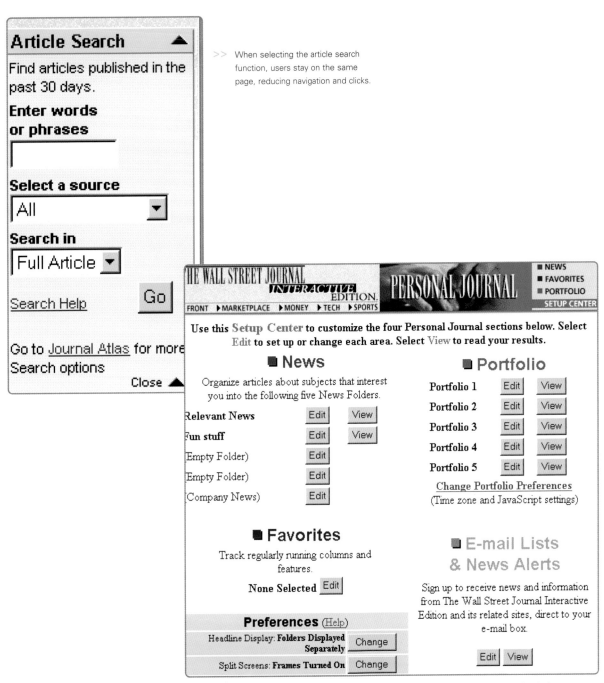

Article Search

Find articles published in the past 30 days.

Enter words or phrases

Select a source

All ▼

Search in

Full Article ▼

Search Help Go

Go to Journal Atlas for more Search options

Close ▲

>> When selecting the article search function, users stay on the same page, reducing navigation and clicks.

THE WALL STREET JOURNAL INTERACTIVE EDITION. PERSONAL JOURNAL

■ NEWS
■ FAVORITES
■ PORTFOLIO

FRONT ▶MARKETPLACE ▶MONEY ▶TECH ▶SPORTS SETUP CENTER

Use this **Setup Center** to customize the four Personal Journal sections below. Select **Edit** to set up or change each area. Select **View** to read your results.

■ News

Organize articles about subjects that interest you into the following five News Folders.

Relevant News Edit View
Fun stuff Edit View
(Empty Folder) Edit
(Empty Folder) Edit
(Company News) Edit

■ Portfolio

Portfolio 1 Edit View
Portfolio 2 Edit View
Portfolio 3 Edit View
Portfolio 4 Edit View
Portfolio 5 Edit View

Change Portfolio Preferences
(Time zone and JavaScript settings)

■ Favorites

Track regularly running columns and features.

None Selected Edit

■ E-mail Lists & News Alerts

Sign up to receive news and information from The Wall Street Journal Interactive Edition and its related sites, direct to your e-mail box.

Edit View

Preferences (Help)

Headline Display: **Folders Displayed Separately** Change

Split Screens: **Frames Turned On** Change

>> The personalization center employs simple buttons and minimal copy to help users customize their *Wall Street Journal* experience quickly and efficiently.

We are constantly challenged by the rapidly developing pace of the web environment.

Insider Trading Spotlight

A look at buying and selling by company insiders. Statistics, provided by First Call / Thomson Financial of Rockville, Md., are updated daily.

▷ **Intent to Sell:** A list of companies with the highest number of insiders filing Form144 with the Securities and Exchange Commission, disclosing their intention to sell restricted stock. *Updated on Mondays.*

▷ **Industry Leaders:** Lists of the industries where insiders have been the most active buyers and sellers of stock. *Updated on Tuesdays.*

▷ **Spotlight:** Lists, as published in The Wall Street Journal, of the biggest individual insider trades of the past week and a rundown of companies with the largest net change in insider ownership. *Updated on Wednesdays.*

▷ **Insider Buying:** A rundown of the 40 companies in the Standard & Poor's 500 with the highest number of insider purchases during the past three months. *Updated on Thursdays.*

▷ **Insider Selling:** A rundown of the 40 companies in the Standard & Poor's 500 with the highest number of insider sales during the past three months. *Updated on Fridays.*

>> Features such as the Insider Trading Spotlight are updated throughout the week.

>> The Spanish-language *Wall Street Journal* follows a similar but more colorful format.

The site is continually updated, more often than once an hour, keeping the news fresh.

>> The career area of *The Wall Street Journal* online provides timely information for both management and prospective employees.

>> Some areas of the site focus on issues outside the office like the home.

PHILIPS

Philips Lighting *TradeLink*℠

News OrderBook Forum Marketing Products

OrderBook

Display [Open Orders ▾] or find Orders by Date: [＿＿＿] or by PO#: [＿＿＿] [Go]

🔍 Search Product Catalog

Date	PO #	Order #	Total	Status	
9/16/99	233376	0030151090	$2,228.24	Partial Ship	🔍
9/9/99	232969	0030147025	$1,155.62	Partial Ship	🔍
8/17/99	983679	0030134161	$11,642.68	Backordered	🔍
8/11/99	231399	0030129969	$8,741.61	Partial Ship	🔍
7/21/99	230307	0030116196	$4,268.38	Backordered	🔍
7/19/99	977406	0030114284	$757.35	Allocated	🔍
7/19/99	977408	0030114283	$1,109.70	Allocated	🔍
7/1/99	229294	0030103904	$8,100.52	Backordered	🔍
6/2/99	227801	0030086947	$1,430.60	Partial Ship	🔍

Icon Legend
🔍 **View** Order Details
🔍 **Search** Product Catalog

>> Above, a compact navigation bar directs users through the site. The OrderBook feature details customer orders and allows users to view details of specific orders and to find orders by date or purchase order number.

The Light Site

- Concentrate on what customers most ask for.
- Don't waste money and energy on extra technology.
- Think speed.

Philips Lighting TradeLink

Providing Customer Service to All Customers

Several years ago, Philips Lighting identified a business problem common to their smaller distributors: Customer service wasn't working for the distributors or for Philips. For the distributors without existing electronic connections to Philips, contacting customer service took valuable time—time better spent servicing their own customers. For Philips, human resources were better spent servicing the bigger, higher-volume distributors.

Solving the Problem

The solution was TradeLink, an extranet designed to allow smaller distributors to access order information, marketing support, and product spec sheets and updates as well as a forum in which to ask and answer questions, both of other distributors and Philips Lighting employees.

"It's a win-win situation. Our distributors can access order information at their convenience as well as enhance their marketing efforts and keep abreast of new product news and development," says Charlie Bowman, manager of electronic commerce for Philips Lighting. "For us, we have a better line of communication with them now than we ever had before."

Because corporate design standards are established by Philips's headquarters in the Netherlands, issues such as color and font were taken care of before site design began. The focus of the design process was thus the effective delivery of information. "Fast and simple were our keywords in building TradeLink," adds Bowman.

Structuring Content

Philips boiled down the content to five crucial areas: News, OrderBook, Forum, Marketing, and Products. To save time for users, the News page is also the home page for the interface, enabling Philips to communicate information in a venue where customers will surely see it. The most accessed feature, though, is the OrderBook; customers can place orders and find complete order status information, including line-by-line shipping status on individual purchase orders.

TradeLink has become popular with Philips's distributors. In fact, 350 customers currently participate in the endeavor, but due to popular demand, all customers will be able to access TradeLink by the end of 2000.

Philips Lighting Company: 200 Franklin Square Drive, P.O. Box 6800, Somerset, NJ 08875-0050, (800) 555-0050

Executives: Bill Tortora, Vice President; Jim Worth, Director; Charlie Bowman, Manager, Electronic Commerce **Design Team:** Internal staff **Toolbox:** HTML/Text editors, ASP, Visual Basic, NT, SQL server

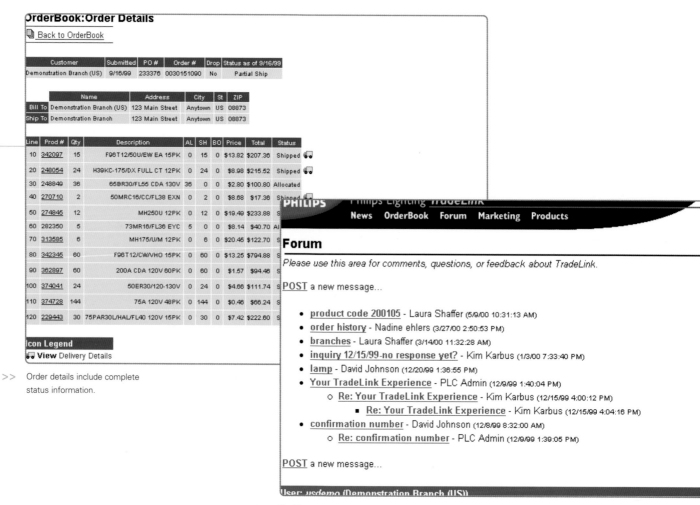

OrderBook: Order Details

📄 Back to OrderBook

Customer	Submitted	PO #	Order #	Drop	Status as of 9/16/99
Demonstration Branch (US)	9/16/99	233376	0030151090	No	Partial Ship

	Name	Address	City	St	ZIP
Bill To	Demonstration Branch (US)	123 Main Street	Anytown	US	08873
Ship To	Demonstration Branch	123 Main Street	Anytown	US	08873

Line	Prod #	Qty	Description	AL	SH	BO	Price	Total	Status	
10	342097	15	F96T12/50U/EW EA 15PK	0	15	0	$13.82	$207.36	Shipped	👓
20	248054	24	H39KC-175/DX FULL CT 12PK	0	24	0	$8.98	$215.52	Shipped	👓
30	248849	36	65BR30/FL55 CDA 130V	36	0	0	$2.80	$100.80	Allocated	
40	270710	2	50MRC16/CC/FL38 EXN	0	2	0	$8.68	$17.36	Shipped	👓
50	274845	12	MH250U 12PK	0	12	0	$19.49	$233.88	S	
60	282350	5	73MR16/FL36 EYC	5	0	0	$8.14	$40.70	Al	
70	313585	6	MH175/U/M 12PK	0	6	0	$20.45	$122.70	S	
80	342345	60	F96T12/CW/VHO 15PK	0	60	0	$13.25	$794.88	S	
90	362897	60	200A CDA 120V 60PK	0	60	0	$1.57	$94.46	S	
100	374041	24	50ER30/120-130V	0	24	0	$4.66	$111.74	S	
110	374728	144	75A 120V 48PK	0	144	0	$0.46	$66.24	S	
120	229443	30	75PAR30L/HAL/FL40 120V 15PK	0	30	0	$7.42	$222.60	S	

Icon Legend
👓 **View** Delivery Details

>> Order details include complete
 status information.

PHILIPS Philips Lighting *TradeLink*

News OrderBook Forum Marketing Products

Forum

Please use this area for comments, questions, or feedback about TradeLink.

POST a new message...

- **product code 200105** - Laura Shaffer (5/9/00 10:31:13 AM)
- **order history** - Nadine ehlers (3/27/00 2:50:53 PM)
- **branches** - Laura Shaffer (3/14/00 11:32:28 AM)
- **inquiry 12/15/99-no response yet?** - Kim Karbus (1/3/00 7:33:40 PM)
- **lamp** - David Johnson (12/20/99 1:36:55 PM)
- **Your TradeLink Experience** - PLC Admin (12/9/99 1:40:04 PM)
 - **Re: Your TradeLink Experience** - Kim Karbus (12/15/99 4:00:12 PM)
 - **Re: Your TradeLink Experience** - Kim Karbus (12/15/99 4:04:16 PM)
- **confirmation number** - David Johnson (12/8/99 8:32:00 AM)
 - **Re: confirmation number** - PLC Admin (12/9/99 1:39:05 PM)

POST a new message...

User: usdemo (Demonstration Branch (US))

>> The Forum area allows users to post questions for
 Philips Lighting personnel or other customers.

" **We have a better line of communication with distributors now**

than we ever did before. "

- **Website Objective:** To improve customer service through a self-serve application and to create an electronic alternative to EDI for smaller customers.
- **Creative Strategy:** Convey timely information to customers in as simple a format as possible.
- **Target Audience:** Smaller customers (for order entry and delivery information); larger customers (for delivery information).

PHILIPS — Philips Lighting *TradeLink*SM

News OrderBook Forum Marketing Products

Say Green, See Green!

Keep energy conservation in the limelight with the newest energy-saving information and products from Philips.

The Green-Lights event format positions you as the expert to both end-user and contractor customers.

The *Green Lights* kit includes:

2 Posters 24" x 18" each
100 Statement stuffers
100 Postcard announcements
1 Tyveck banner 10' x 13'
2 Static cling stickers
10 Buttons
1 Clip art sheet
Promotional ideas booklet

>> Customers can access detailed marketing advice and support for different product lines.

PHILIPS — Philips Lighting *TradeLink*SM

News OrderBook Forum Marketing Products

ALTO™ 4-foot T8 Fluorescent Lamps

Environmentally responsible without sacrificing performance.

- **A First**
 The first fluorescent lamps that pass the U.S. EPA's test for non-hazardous waste

- **Low-Mercury**
 Reduction in mercury content of more than 80% when compared to standard fluorescent lamps

- **Outstanding Performance Over Life**
 Exclusive Cathode Guard ensures superior lumen maintenance throughout lamp life and reduces lamp end blackening

>> Complete product specification sheets are available online.

May 4, 2000

NOW AT FORRESTER

Home Page

CLIENT LOGIN
GUEST LOGIN

Products
Events
Press Resources
Investor Information
The Company

Site Map

Contact Us
Help

Search

Become a Forrester
- Client
- Affiliate
- Employee

B2B *Insights*
eMarketplaces Redefine Business

- **George F. Colony's My View: Hollow.Com**
- **SAP Partners With Clarify: Too Little, Too Late**
- **MP3.com And The RIAA Should Make Friends**
- **Forrester Research Predicts The Imminent Demise Of Most Dot Com Retailers**
- **Baseline Research: Research For Internet Entrepreneurs**

The Business Voyage™ FORRESTER

Move fast. Move smart.

PowerRankings™
eCommerce Rankings You Can Trust

Click to rank eCommerce sites

QUOTE OF THE DAY
By: Lisa Allen

get Connected

THE *1999* ANNUAL REPORT

NOW OR NEVER
BY MARY MODAHL
NOW AVAILABLE!

FORRESTER'S LEADING INTERNET RESEARCH

Our research spans consumer, business-to-business, and technology marketplaces. Forrester offers comprehensive analysis of the global Internet Economy and its impact on society and business.

SEARCH OUR RESEARCH:

[] GO

>> The home page sets the look and feel of the site through the use of fonts, vivid colors, and clean icons.

Helping Businesses Thrive on Technology Change

- Break information into manageable pieces.
- Keep the design simple and scalable.
- Present a consistent user interface.

21
Forrester Research

Making Research Enjoyable

Mention the word research and most people yawn or cringe. It's a necessary evil in the business world, but few people like to do it. The Forrester Research website goes a long way toward making research enjoyable. Active colors, text, and images invite visitors to explore and make it easy for existing clients to locate what they're looking for, whether it be evaluations of software or technology industry trends.

The Approach

"We approached designing the site from an information architecture point of view," says Richard Belanger, chief technology officer for Forrester. "We asked ourselves how we could simplify the process of finding and consuming our research."

The result is a website that's easily and intuitively navigated and avoids unnecessary information and graphics while remaining visually interesting. Each report is broken into manageable pieces, allowing users to find specific reports and access interviews, analyses, and specific real-world applications without having to wade through unwanted information. Simple text-based icons used throughout the site provide a legend for users, and varying shades of the palette established on the home page unify the presentation.

Other customer-friendly features include cross-referenced companies and research, concise report summaries written in conversational English, and the ability to print reports either in a printer-friendly HTML format or by downloading a printable Acrobat file. A combination of vertical and horizontal pieces on each page helps lead users through the layout.

"The end result is a simple design combined with a comprehensive technology solution that allows Forrester to deliver a seamless client experience," adds Belanger.

Forrester Research: 400 Technology Square, Cambridge, MA 02139, (617) 497-7090

Executives: William M. Bluestein, Ph.D., President and Chief Operating Officer; Richard C. Belanger, Chief Technology Officer; Stan Dolberg, Vice President, Research; Mary Modahl, Vice President, Marketing Design Team: Internal: Eva Pederson, Rebecca Lord; External: Corey, Macpherson & Nash, Watertown, MA Toolbox: Vignette StoryServer, Photoshop, Adobe Illustrator, Microsoft Word, Microsoft Excel, Microsoft PowerPoint

THE FORRESTER REPORT

QUICK VIEW

Automating eBusiness

May 2000

EDI-based trading systems won't [] utomated eBusiness needs. To truly raise [] []lock speed, firms must create autom[] []n chains -- and free people to ha[] []ional situations.

by Joseph L. Butt, Jr. with Carl D. Howe, Steven D. [] []ie Smith, Christopher Voce

FORRESTER

Home Page

CLIENT LOGIN

GUEST LOGIN

Products
Events
Press Resources
Investor Information
The Company

Site Map

Contact Us
Help

Search

Become a
Forrester
- Client
- Affiliate
- Employee

>> The left-hand navigation bar maintains the color scheme while taking up little screen space.

>> Concise, friendly copy helps users make quick decisions about the relevance of each report to their needs.

A combination of vertical and horizontal pieces on each page helps lead users through the layout.

- **Website Objective:** To provide a set of tools and functions that allows clients to explore Forrester Research in any way that fits their needs and to provide a comprehensive overview of Forrester for prospects, the press, and the general public.
- **Creative Strategy:** Make it as easy as possible for clients to find the right research.
- **Target Audience:** Senior executives at Global 2500 companies and Internet start-ups.

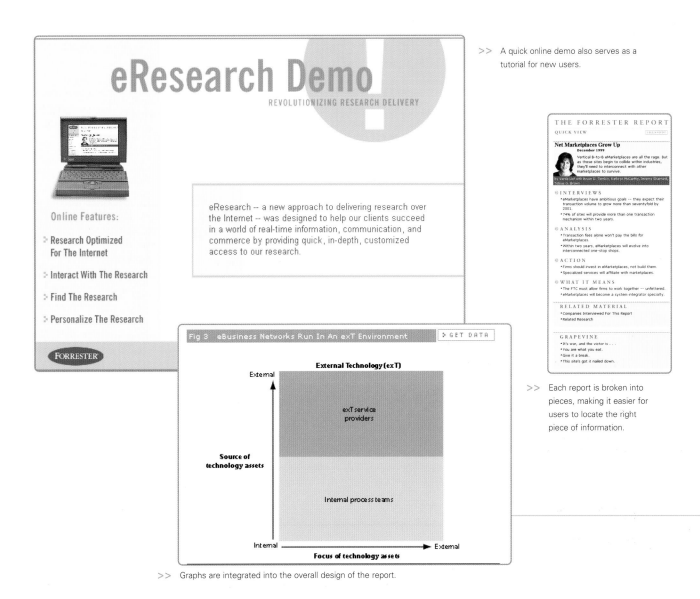

>> A quick online demo also serves as a tutorial for new users.

>> Each report is broken into pieces, making it easier for users to locate the right piece of information.

>> Graphs are integrated into the overall design of the report.

THE FORRESTER BRIEF

Vivendi Will Water Down Seagram

June 21, 2000

A water company and a liquor firm? No. Seagram and Vivendi's $34 billion deal unites a European access player with a US entertainment group. Vivendi contributes a mobile phone network in France as well as a Pan-European digital TV network. Seagram has Universal film, TV, and music, plus 44% of USA Network.

by Carsten Schmidt with Josh Bernoff, Daniel P. O'Brien

The firms' vision of creating a world-leading new media company will fail. Vivendi can't favor Universal content on its wires -- distribution must seek best-of-breed content to serve user demand for variety. >NOTE Forrester also worries that cultural differences among the stiff managers of Vivendi and the free-spirited execs at Seagram will slow down innovation and expansion.

- **Big-pipe and content companies must resist the urge to merge.** The access/content trend that started with AOL/Time Warner and Lycos/Terra Networks has gone too far. Access companies like UPC in Europe or Charter in the US must resist pressure to find content partners before the music stops. Content players like Bertelsmann and Disney should instead concentrate on spreading their content as widely as possible to boost their content brands across channels.

- **Retailers and content companies must insist on fair deals.** Companies like Amazon.com or MGM/UA must make sure that their deals with these new distribution/content firms give them equal rights with in-house content groups. These companies must stress the quality of both their products and the audience they draw and demand first-rate deals for their first-rate content.

- **Open access plays can zip past walled gardens.** As Vivendi's Canal Plus and Cegetel erect walls with proprietary content, competitors like Open and Vodafone should succeed by drawing customers away with open offerings and aggressive investments in new technologies like UMTS licenses. >NOTE

This document is relevant to the following lenses:

> European Internet Commerce
> Internet Commerce
> New Media
> European New Media
> Future Of TV & Entertainment

For more information about any of Forrester's lenses, contact us.

^TOP

>> Important points in analysts briefs are bulleted to help readers quickly understand the information.

Forrester Research - Glossary - Microsoft Internet Explorer

GLOSSARY

Search Glossary: [] GO

A B C D E F G H I J K L M N O P Q R S T U V W X Y Z 1-9

ACD
action-driven design
active networks
active networks
activity-based funding
ADSL
advice
ANSI

Welcome to the Forrester Online Glossary.

This glossary contains definitions to Forrester-coined words and terms as well as many commonly used acronyms. Definitions of Forrester terms are taken from Forrester Reports and Briefs.

Please contact us with your suggestions for the Forrester Glossary.

>> An online glossary can be accessed anytime.

>> Forrester events, such as workshops and forums, are listed for both current and potential customers

>> Searchable help pages make it easy for customers to find the right tips and information.

Active colors, text, and images invite visitors to explore.

>> All information on the BNG extranet is accessible through the initial frameset.

Screen-Based Services for BNG Customers

- If you have a text-heavy site, make the environment as visually interesting as possible.
- Create navigation that is easy for the customer to use.
- Use contrasting color elements in moderation to help keep static information interesting.

22

Bank Nederlandse Gemeenten

A Different Kind of Bank

Bank Nederslandse Gemeenten (BNG) acts as the principal Dutch public-sector banking agency. Lending is limited to central and local governments, state-owned entities, and state-guaranteed institutions within the European Union. As a result, BNG customers look for highly specialized business information from the bank.

The challenge in designing the extranet for BNG Data Services was to make a complex information structure look and feel easily accessible. BNG's customers are completely business oriented and want to access relevant information as quickly as possible. At the same time, BNG wanted to update their standard, staid corporate identity while remaining within corporate design guidelines. "In addition to balancing the corporate design standards, designing a new look for the Data Services area, and integrating the information structure, we also had to translate an offline prototype into a working online environment compatible with Internet Explorer and Navigator," said Gijs Garcia Bogaards, senior designer with netdesign.nl.

Updating the Look

The primary corporate site for BNG features dark teal frames and a text area with black text on a white background. To modernize the image of the extranet site, netdesign.nl increased the white space and varied the shades of teal to open the appearance of the screen. In addition, bright orange is incorporated to highlight the title of the page being viewed and to feature important icons, including a mail-to function and page-print feature. Because the core information is almost completely text based, these lighter, brighter design elements help keep the site visually interesting.

"We wanted to make sure that all information was accessible from within the initial frameset," says Bogaards, "So we had to update the navigation as well as the look and feel."

nv Bank Nederlandse Gemeenten: P.O. Box 30305, 2500 GH The Hague, Netherlands, 31 (0)20 422 0850

Executives: Jan Visser, Ron Zwetsloot **Design Team:** Netdesign.nl: Gijs Garcia Bogaards, Earl de Wijs, Andy Tjin **Toolbox:** Photoshop, Adobe ImageReady, Allaire Homesite, Ultra-edit, Perlscript

>> bng-02-WEContrasting orange highlights special features and the page currently in view.

Informatie over deze pagina

Dit veld bevat extra informatie over de pagina die u op dit moment voor u heeft. Hier vind u informatie over de structuur van de pagina en uitleg over eventuele functionaliteiten die gekoppeld zijn aan deze pagina.

>> Separate information windows are launched when accessed so that users never leave the pertinent data.

Netdesign.nl increased the white space and varied the shades of teal to modernize the image of the extranet site and open the appearance of the screen.

- **Website Objective:** To provide clients with a broad variety of financial and nonfinancial information.
- **Creative Strategy:** Give BNG a modern face on the Internet. Keywords for the design were transparency, feeling of value, trustworthiness, and clearness.
- **Target Audience:** Customers from The Netherlands who are provided with a username and password.

>> Information search functions are boiled down to the most basic elements.

>> A simple, compact navigation bar makes it easy to get around but takes up little valuable screen space.

>> A no-frills, well-integrated shopping cart is the last stop before final purchase.

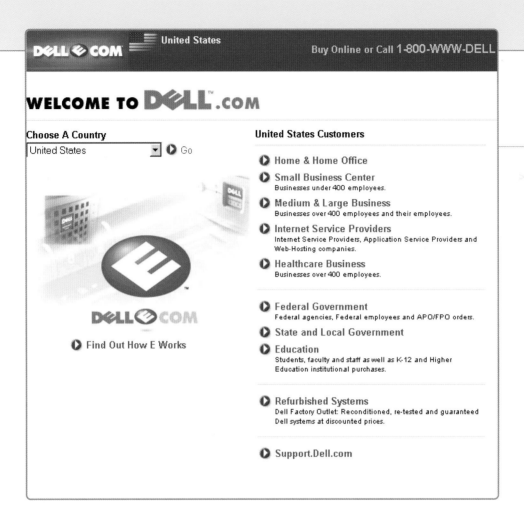

WELCOME TO **DELL**.COM

Choose A Country

United States ▾ ● Go

DELL ● COM

● Find Out How E Works

United States Customers

● **Home & Home Office**

● **Small Business Center**
Businesses under 400 employees.

● **Medium & Large Business**
Businesses over 400 employees and their employees.

● **Internet Service Providers**
Internet Service Providers, Application Service Providers and
Web-Hosting companies.

● **Healthcare Business**
Businesses over 400 employees.

● **Federal Government**
Federal agencies, Federal employees and APO/FPO orders.

● **State and Local Government**

● **Education**
Students, faculty and staff as well as K-12 and Higher
Education institutional purchases.

● **Refurbished Systems**
Dell Factory Outlet: Reconditioned, re-tested and guaranteed
Dell systems at discounted prices.

● **Support.Dell.com**

>> When users enter the dell.com site, they are asked to identify their country and the types of products they are interested in.

The Best in Online Computer Sales and Support

- On a complex site, keep the design elements minimal.
- Segment visitors as soon as possible so they can find what they're looking for faster.
- Make sure the navigation tools provide access to all areas of the site.

23

Dell

Presenting a Coherent Message

The volume of information provided on the Dell Computer site is stunning. Dell utilizes the site as a commerce engine, a customer support tool, and an information resource for a base of users that includes individual buyers, corporate accounts, educational institutions, and government agencies around the world. The opportunities to blur the brand or lose the customer in the navigation are countless. Despite the site's multiple objectives, however, it remains supremely customer-friendly.

Segmenting the Marketplace

Dell recently redesigned the site to better serve the 40 million online visitors it hosts per quarter. The overarching strategy is to customize the experience as much as possible so that users can access the right information and products as quickly as possible. International customers are routed to country-specific sites and further segmented by the type of business operation they represent. This way, home computer customers don't have to sift through server information, and government customers see only products approved for purchase by the government.

The customer support area of the site (support.dell.com) is unparalleled among online computer retailers. Users enter basic information regarding their systems and support needs and are then directed to a customized page where they can ask questions, download software, sign up for online learning, check the status of an order, and consider at least a dozen more options. A series of unobtrusive navigation bars at the top of the screen enable users to find their way to literally any other area of the Dell site.

The Look and Feel

On the top-level pages, where it's crucial that customers know where they're going, only blue is used to enhance black text on a white background. Once users access the pages for their market segment, other colors gradually creep in, but on a limited basis. Throughout the site, the color scheme remains subdued, allowing users to focus on the information.

Dell: One Dell Way, Box 8109, Round Rock, TX 78682, (800) WWWDELL

Executives: Dave Hood, Vice President, Online for Home and Small Business Markets; Patrick Vogt, Vice President, Online for Corporate Markets; Sally Woolsey, Vice President, Online for Public Markets **Design Team:** Internal Dell staff, Frog Design, Austin **Toolbox:** Microsoft platform tools, internally developed software, XML

17　18　19　20　21　22　**23**　24　25　26　27　28　29　30

Dell recently redesigned the site to better serve the 40 million online visitors it hosts per quarter.

>> Colors are sparingly added to the standard blue-and-white scheme.

>> Dell personalizes customer support with minimal input from the customer.

- **Website Objective:** To create an online presentation for all of Dell, including sales of product, customer support, and general information.
- **Creative Strategy:** To present a tremendous volume of information in a visually pleasing way.
- **Target Audience:** Enormous—individual consumers, small businesses, large corporations, government, education institutions, international organizations.

Online education courses are recommended based on the user's input.

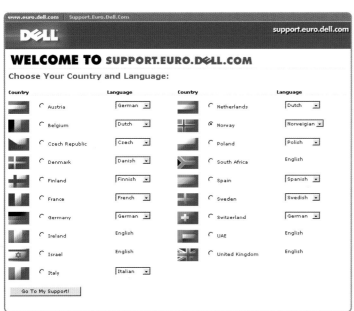

Customers identify their country and choose a language before being directed to a regional support site.

Condensed navigation bars simplify movement throughout the site.

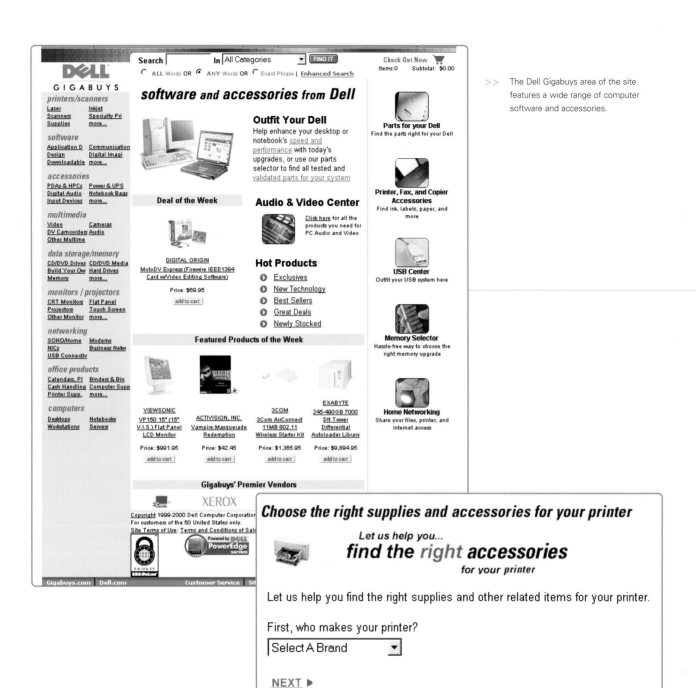

>> Customers can search by brand to locate the products they need.

DELL
GIGABUYS

Search | In |All Categories| ▼ | **FIND IT** | Check Out Now 🛒
○ ALL Words OR ● ANY Words OR ○ Exact Phrase | **Enhanced Search** | Items:0 Subtotal: $0.00

Home >> Printer Consumables >> HEWLETT PACKARD >> LASERJET 4 PLUS 8PPM (C2037A) >> PRINTER SUPPLIES AND ACCESSORIES SELECTOR

(Items 1 - 4 of 4) | (Page 1 of 1)

Manufacturer	Product	Add to Cart	Price	In Stock
HEWLETT PACKARD	LASER TONER, BLACK, EX ENGINE, EPE, IV/IVM, Single-Color Cartridge, Black	ADD	$83.95	✔
HEWLETT PACKARD	LASER TONER, BLACK, EX ENGINE, EPE, IV/IVM, Single-Color Cartridge, Black, 8800 Pages	ADD	$92.95	✔
HEWLETT PACKARD	LASER TONER, BLACK, EX ENGINE, EPE, IV/IVM, Single-Color Cartridge, Black, 6800 Pages	ADD	$377.95	✔
HEWLETT PACKARD	LASER TONER, LOW YIELD, 4000 PAGE YIELD Single-Color Cartridge, Black, 4000 Pages	ADD	$61.95	✔
Manufacturer	Product	Add to Cart	Price	In Stock

>> Manufacturer, product, price, and availability are all included on a search results page.

Customer Service

Welcome to customer service. We have thousands of products from today's favorite manufacturers. We've organized it all to make it easy to find what you're looking for, and added extensive product information to help you can make the right purchase decisions. If you need help, please use the options below.

How To Shop
New to online shopping, or just new to our site? Here's what you need to know to shop our virtual aisles.

FAQs (Frequently Asked Questions)
Maybe we've already answered your question! Check out our technical, shopping, and site FAQs.

Contact Us
Need further information, or maybe just a human touch? Here's where to find it.

Order Status
Check on the status of your order using the Dell Order Tracking Tool.

Policies
Information you might need regarding warranties, shipping, and returns.

How Do I Choose An Online Retailer?
Here are some things to think about when it comes to shopping online.

Customer Comments
Here's what other shoppers have to say about us.

Site Map

>> A logically organized customer service area guides users to the right information.

>> Contact information for all types of customers is provided on the Contact Us page.

>> A clean site map allows customers to navigate throughout the site.

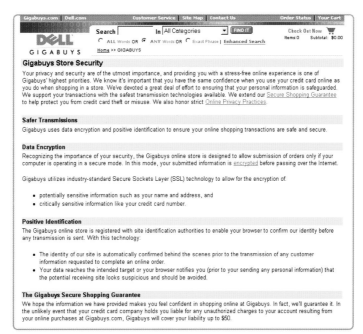

>> Users may register to receive updates and special product information from Dell.

>> Dell's privacy policy is outlined in detail for users.

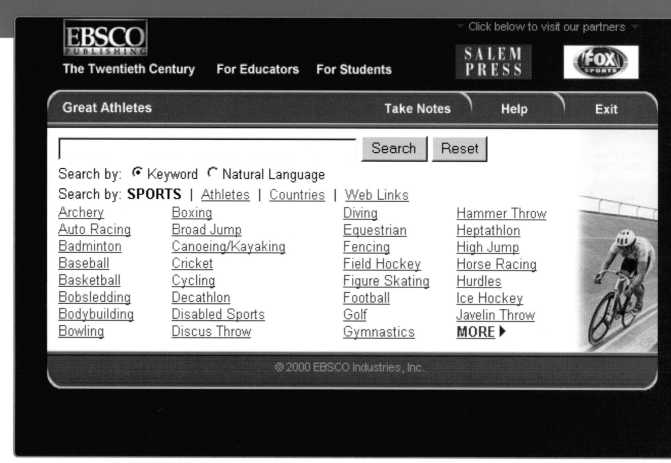

EBSCO
PUBLISHING

The Twentieth Century For Educators For Students

▼ Click below to visit our partners ▼

SALEM PRESS

FOX SPORTS

Great Athletes Take Notes Help Exit

[] [Search] [Reset]

Search by: ● Keyword ○ Natural Language
Search by: **SPORTS** | Athletes | Countries | Web Links

Archery	Boxing	Diving	Hammer Throw
Auto Racing	Broad Jump	Equestrian	Heptathlon
Badminton	Canoeing/Kayaking	Fencing	High Jump
Baseball	Cricket	Field Hockey	Horse Racing
Basketball	Cycling	Figure Skating	Hurdles
Bobsledding	Decathlon	Football	Ice Hockey
Bodybuilding	Disabled Sports	Golf	Javelin Throw
Bowling	Discus Throw	Gymnastics	**MORE** ▶

© 2000 EBSCO Industries, Inc.

>> Simple and compact, the home page interface presents all the navigation options and a search function.

Great Athletes of the Twentieth Century

- Make sure users can access the core information quickly.
- Present the navigation options together in one place.
- Make it easy for customers to use the content any way they want.

24
EBSCO Publishing

The Ultimate Academic Research Environment

Every once in a while, a product comes along that makes one of life's basic tasks significantly easier. With Great Athletes of the Twentieth Century, EBSCO Publishing has created an online environment that brings together everything a student, librarian, or teacher needs when researching a sports topic. On top of that, the business model is completely scalable, enabling EBSCO to develop more products on essentially the same platform.

The Juggling Act

Because the product is accessed by children as young as twelve years old, the interface itself must be simple and intuitive. In addition, most users access the site from academic environments, such as public schools and libraries, where bandwidth is at a premium. EBSCO's partners in the product, Salem Press and Fox Sports, are showcased without eating up precious screen space.

The Great Athletes interface focuses on getting users to the information as quickly as possible. All of the critical navigation elements are condensed into the top 35% of a 640 x 480 screen. It takes only three clicks to access the core database content—articles about the featured athletes. Once on the featured athlete page, users can print, e-mail, or save the information to be reviewed later and access additional resources in the form of magazine and newspaper articles, charts, images, and related web links. The real gem of the interface, though, is the Citation Builder feature. While at any article, users can activate a new browser window and automatically build an MLA-style citation, which is stored in their notes. They can also take notes on the material in the citation, then print or e-mail the notes to themselves for later use or review.

What Makes the Site Work

"We worked hard to get inside the mind of the user for this product," says Mike Bucco, product manager, reference publishing, for EBSCO. "Making sure it was easy to get to the basic information was our top priority." A simple palette of red and blue frames the core content and allows customers to focus on the information they need.

EBSCO Publishing: 10 Estes Street, Ipswich, MA 01938, (978) 356-6500

Executives: Michael Bucco, Product Manager, Reference Publishing **Design Team:** River Logic **Toolbox:** XML, Oracle

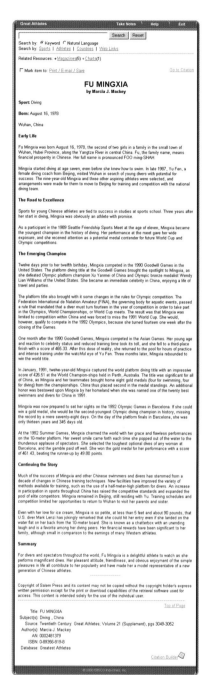

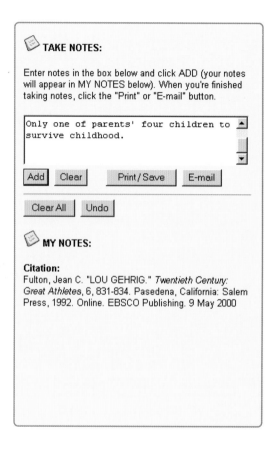

>> The featured athlete pages offer the core database information as well as links to related resources.

>> The Citation Builder and note-taking interface help users remember why a particular article is relevant.

"

A simple palette of red and blue frames the core content and allows customers to focus on the information they need.

"

- **Website Objective:** To create an online research environment for sale to library markets, leveraging existing database product.
- **Creative Strategy:** To make accessing the information as quick and easy as possible.
- **Target Audience:** Students in grades 5 and 6 through junior college.

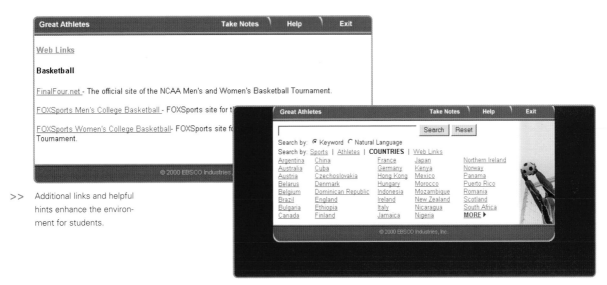

>> Additional links and helpful hints enhance the environment for students.

>> Sorting functions make it easy to find the right resource.

>> An intuitive interface allows users to print, e-mail, or save selected research.

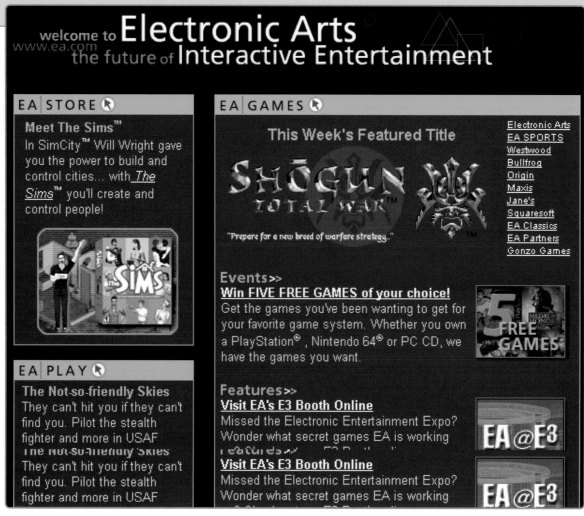

welcome to **Electronic Arts**
www.ea.com
the future of **Interactive Entertainment**

EA STORE

Meet The Sims™
In SimCity™ Will Wright gave you the power to build and control cities... with *The Sims™* you'll create and control people!

EA PLAY

The Not-so-friendly Skies
They can't hit you if they can't find you. Pilot the stealth fighter and more in USAF

EA GAMES

This Week's Featured Title

SHŌGUN TOTAL WAR™

"Prepare for a new breed of warfare strategy.."

Electronic Arts
EA SPORTS
Westwood
Bullfrog
Origin
Maxis
Jane's
Squaresoft
EA Classics
EA Partners
Gonzo Games

Events >>
Win FIVE FREE GAMES of your choice!
Get the games you've been wanting to get for your favorite game system. Whether you own a PlayStation®, Nintendo 64® or PC CD, we have the games you want.

Features >>
Visit EA's E3 Booth Online
Missed the Electronic Entertainment Expo? Wonder what secret games EA is working

Visit EA's E3 Booth Online
Missed the Electronic Entertainment Expo? Wonder what secret games EA is working

>> A black-background home page highlighted by vivid turquoise welcomes gamers to the Electronic Arts site.

The Future of Interactive Entertainment

- Game support sites should mimic the same environment as the product.
- Use incentives to drive customers to the purchasing area.
- Make checkout as fast a process as possible.

25
Electronic Arts

Gamers

Ask anyone who has ever worked in the software games industry and they'll tell you that "gamers," as the devotees of the medium are known, are an unusual bunch. Often portrayed as geeks who never see the light of day, they constitute a devoted and reliable group of consumers who can spend hours a day talking to each other about the games they're currently playing and which companies develop the games with the best graphics, most realistic action, or greatest challenge.

The ea.com Presence

As one of the largest developers of software games, Electronic Arts must design their website to cater to gamers of every interest and ability level. Customers can access information on new games, purchase games and hint books, receive customer support, download software patches, and play games online with fellow gamers.

Electronic Arts produces a wide range of titles from RoadRash Jailbreak to FIFA 2000 Major League Soccer to Jane's USAF flight simulator. Because the audience is so varied, each Electronic Arts title has its own support or promotional site within the larger Electronic Arts presence.

A New Twist to Becoming a Member

Instead of inviting users to log in on the ea.com home page, Electronic Arts site members access their benefits via the store's home-page (www.ea.com/store), thereby driving customers to the revenue-producing area of the site. Membership benefits include discounts on selected items, notification by e-mail regarding promotional sales offers/events, and access to members-only sites. In addition, membership in the EA Store enables customers to check on the status of an order at their convenience.

The basic color theme for the Electronic Arts site, a black background with bright blue highlights, gives the feeling of being inside a software game. This framework also enhances product views and screen shots, most of which feature the same glowing colors on a dark background. The checkout process is quick and painless, especially if customers are already registered as a member of the EA Store.

> **Focusing on the enthusiasm of the gamer audience, Electronic Arts adds a new twist to the EA Store.**

Electronic Arts: 1450 Fashion Island Boulevard, San Mateo, CA 94404, (650) 571-7171

Executives: John Riccitiello, President, ea.com **Design Team:** Inhouse **Toolbox:** Frames, Photoshop, HTML

- **Website Objective:** Create an online environment that is welcoming to the gamer audience. Encourage sales.
- **Creative Strategy:** Mimic the look and feel of an interactive game.
- **Target Audience:** Mostly males ages 13–45.

>> The EA Store features special deals and the ten most popular Electronic Arts software.

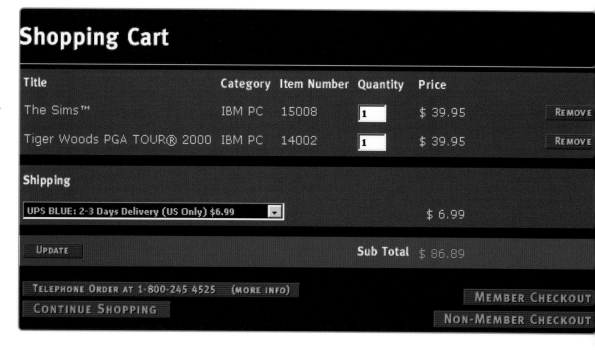

>> The shopping cart details the items purchased, including item numbers, and offers a toll-free number for customers who don't want to purchase over the Internet.

>> The bright blue EA navigation banner is superimposed on all pages of the site.

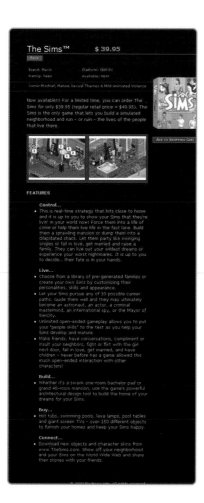

>> Screens shots, ratings, platforms, and detailed descriptions of features constitute the product information screens.

>> The store navigation bar enhances the concept of the EA Store as a members-only area.

Electronic Arts must design their website to cater to gamers of every interest and ability level.

>> Small promotional windows maintain the same look and feel as the rest of the site.

>> Users can access support through title or brand and platform.

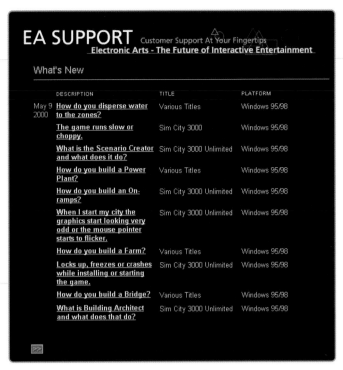

EA SUPPORT Customer Support At Your Fingertips
Electronic Arts - The Future of Interactive Entertainment

What's New

	DESCRIPTION	TITLE	PLATFORM
May 9 2000	**How do you disperse water to the zones?**	Various Titles	Windows 95/98
	The game runs slow or choppy.	Sim City 3000	Windows 95/98
	What is the Scenario Creator and what does it do?	Sim City 3000 Unlimited	Windows 95/98
	How do you build a Power Plant?	Various Titles	Windows 95/98
	How do you build an On-ramps?	Sim City 3000 Unlimited	Windows 95/98
	When I start my city the graphics start looking very odd or the mouse pointer starts to flicker.	Sim City 3000 Unlimited	Windows 95/98
	How do you build a Farm?	Various Titles	Windows 95/98
	Locks up, freezes or crashes while installing or starting the game.	Sim City 3000 Unlimited	Windows 95/98
	How do you build a Bridge?	Various Titles	Windows 95/98
	What is Building Architect and what does that do?	Sim City 3000 Unlimited	Windows 95/98

>>

>> The advantages of joining the EA Store are touted throughout the site.

Driving customers to the store increases the chance that they will purchase products.

chapter 4

>> Consumer and Retail Sites >> Finance, Banking, and Business-to-Business Sites

Not every electronic commerce site involves an elaborate shopping cart and checkout process or requires a password to access important content. Some of the most innovative e-commerce concepts involve creating online environments that either enhance an offline product or create a marketplace that couldn't operate effectively anywhere else. Still others utilize the Internet only to gather information to initiate the sales process; deals are closed on the phone or in person.

 ab2000 (p. 182) created an online facsimile of a trade show to help promote the show and to generate interest among potential participants. The virtual component turned out to have more advantages than anticipated. Says Earl de Wijs, a designer for netdesign.nl, the firm that developed the site, "We wanted to create a virtual fair with all the possibilities of a real fair for exhibitor and visitor, without the typical physical

Other e-commerce Sites

limitations of a trade convention. Every part and function of the fair is in reach at all times, whatever the visitor is doing." Visitors don't have to walk from one end of the exhibition hall to the other to visit the vendor they are interested in when they access the fair online.

Creating an online matchmaker for small businesses and service providers presented unique challenges for bSource.com (p. 164). "We're trying as much as possible to recreate a personal experience online," says Paul Smith, CEO. "Ultimately, you're choosing people you're going to work with, so we're essentially trying to help people fall in love with their business service firm."

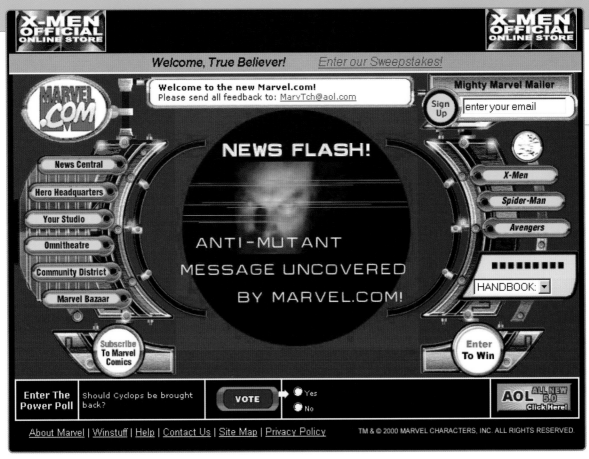

>> There's no mistaking arrival at the Marvel website: spaceship graphics and "anti-mutant" messages welcome the visitors.

Bringing the Marvel Universe
a Little Closer to Your Reality

- Stay on top of the brand; make sure customers can identify the site.
- Give users a way to participate in site content to enhance retention.
- Take advantage of ways for partners to handle order fulfillment.

26
Marvel Comics

A Brand Destined for the Online World

If any brand from the print world is destined to make a smooth transition to the Internet, it's Marvel. The stories of Spider-Man, the X-Men, and the Avengers have always taken place in a fictional locale, so why not cyberspace?

"We utilize the web's promise of interactivity and direct reach by giving visitors ways of demonstrating their own creativity. Fans can rewrite a panel from a Marvel comic in the Marvel Makeover, submit a drawing of a Marvel hero or villain to our Fan Art Museum, or try their hand as a storyteller in To Be Continued," says Gregg Sanderson, editorial director for marvel.com.

Accessing Marvel Merchandise

Because Marvel fans tend to be such hard-core believers, marvel.com sells comics (both new publications and classics), sculptures, original art, and other related merchandise. Sometimes Marvel processes orders, such as comic subscriptions, and sometimes they link directly to other vendors who own the rights to sell Marvel merchandise. Either way, they're making money and, in many cases, they're reducing the headaches of fulfillment.

When users go online to order comics from Marvel, the interface is basic. "Delivering the Marvel experience to a low-bandwidth audience requires constant juggling," says Sanderson. "To ensure a successful and secure connection, the online ordering interface has to stay extremely simple."

Making Value-Added Content Valuable

Marvel.com is a great venue in which Marvel can strut its world-class storytelling stuff to a worldwide audience. The Marvel site feels exactly the way it should: like you've stepped into a comic book. It features lots of blacks and grays contrasted with bright, cartoonish colors and a navigation interface reminiscent of a spaceship control panel. Episodic stories in a web comic format and amazing web animation in Excelsior Theater enhance the comics and Marvel entertainment properties without seeming wholly self-serving.

Marvel Comics: 387 Park Avenue South, New York, NY 10016, (212) 696-0808

Executives: Bill Jemas, President of New Media and Publishing; Gregg Sanderson, Editorial Director, Marvel.com **Design Team:** Xceed New York, in-house design staff **Toolbox:** DreamWeaver, BBEdit, Photoshop, Illustrator, Director, Flash

>> A control panel navigation bar directs users to featured areas of the site.

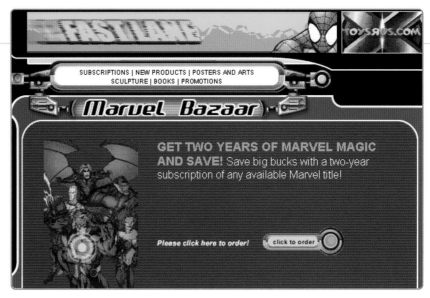

>> Bright colors and obvious navigation bring users to the subscription area.

>> Online order forms are available for residents around the world. Plus Marvel provides a printable order form for users who wish to fax or mail.

- **Website Objective:** Create an entertainment and information website to support and reflect all of Marvel's efforts as an entertainment company.
- **Creative Strategy:** Bring the world of Marvel online and provide fans with an opportunity to become further involved in the Marvel universe.
- **Target Audience:** Predominantly male, ages 12–35.

>> Links to other vendors of Marvel merchandise round out the online shopping area.

>> A simple checkbox order interface accommodates the widest possible audience.

>> Marvel fans can participate in ongoing storylines in the Your Studio area.

>> An entire area of the Marvel site is dedicated to special contests.

The Marvel site feels exactly the way it should: like you've stepped into a comic book.

> **If any brand from the print world is destined to make a smooth transition to the Internet, it's Marvel.**

>> Online cybercomics add another dimension to the Marvel superheroes.

>> Opinions and chat are encouraged in the Community District.

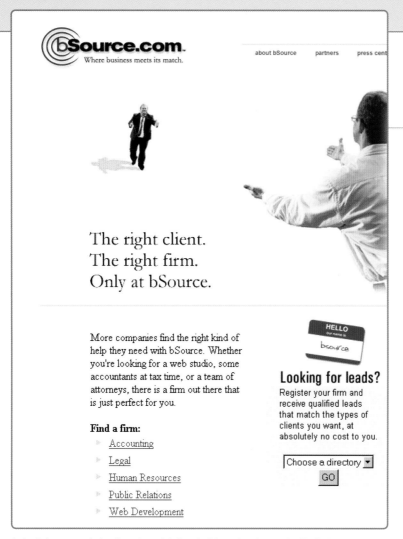

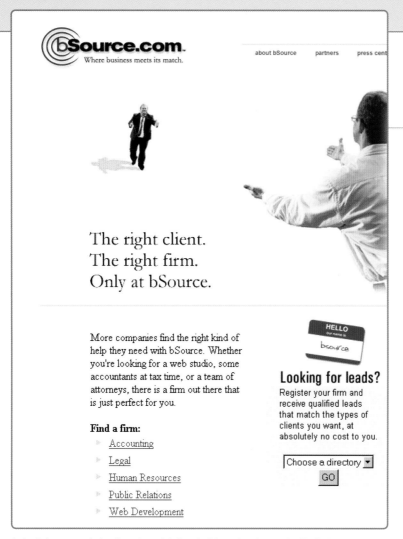
Where business meets its match.

about bSource partners press cent

The right client.
The right firm.
Only at bSource.

More companies find the right kind of help they need with bSource. Whether you're looking for a web studio, some accountants at tax time, or a team of attorneys, there is a firm out there that is just perfect for you.

Find a firm:

▹ Accounting
▹ Legal
▹ Human Resources
▹ Public Relations
▹ Web Development

HELLO
our name is
bSource

Looking for leads?
Register your firm and receive qualified leads that match the types of clients you want, at absolutely no cost to you.

Choose a directory ▾
GO

>> A simple home page helps clients jump right into the information they need while firmly establishing the bSource brand.

Where Business Meets Its Match

- Make information the hero.
- Make the environment feel familiar to the user.
- Make the site convenient both through navigation and content.

27
bSource.com

An Electronic Marketplace

Many e-commerce entrepreneurs have attempted to create new products and markets online. bSource has done the opposite; they've taken the ages-old concept of matchmaking and transferred it to an online business environment, helping small- to medium-sized businesses and departments locate professional service firms—and, as a result, helping small- and medium-sized service firms find qualified clients.

Matching Buyers to Sellers

The engine behind bSource.com is an incredible algorithm that makes matches based on buyers' and sellers' individual needs. This complicated process is made simple to users through a clean interface that actually makes filling in the profile and requesting results easy, even enjoyable.

"We're trying as much as possible to re-create a personal experience online," says Paul Smith, cofounder and CEO of bSource. "Ultimately, you're choosing people you're going to work with, so we're essentially trying to help people fall in love with their business service firm."

The Crucial Elements

There's nothing at all flashy or fancy about the bSource site. Standard blues and grays comprise the color palette, but there's also a humorous image of two executives running toward each other with outstretched arms and witty promotional pieces throughout the site. The pervasive holistic balance of business, marketing, and emotion makes bSource stand out, both on the page and against the competition. This simple concept also makes co-branding efforts easier for the bSource team; the neutral color scheme of the website complements almost any business website design.

"Our goal is to make sure that we're convenient to both the buyer and the seller," adds Smith. "The easier the site is to use and the more helpful feedback and information our customers can find, the higher our rate of retention. They have to find us valuable as well as easy to work with. We're creating an atmosphere of cooperation and collaboration."

bSource.com: 415 Bryant Street, San Francisco, CA 94107, (415) 644-9800

Executives: Paul Smith, CEO; Steve Kirsh, Vice President, Channel Development; Roland Deal, Vice President, Business Development; Michael Olch, Vice President, Marketing; Lori Atwood, Vice President, Finance **Design Team:** Internal staff **Toolbox:** HomeSite, DreamWeaver, Photoshop, Linux, MS SQL

Hints

Project Types, Time Frames and Costs.

Listed below are brief descriptions of various online project types with their approximate time frames and an estimated range of costs. Specific project deliverables can vary greatly depending upon the overall project scope.

- ▶ Full Web Solution
- ▶ E-commerce
- ▶ Design
- ▶ Consulting
- ▶ Online Marketing

Full Web Solution
If you are unsure of your specific needs but know that your project will involve the design, programming and maintenance of a site, a full web solution is an appropriate selection. However, your budget will be the key factor that determines what level of solution makes the most sense. Below are 3 categories to explore.

• Small Web Solution
A marketing driven site made up of several sections. It is typically made up of less than 20 pages and highlights a company's background, products/services, PR, contact info and job openings.
➡ Typical Budget & Time Frame: $10,000-$25,000; 4-6 weeks

• Mid-size Web Solution
This involves an initial strategic overview, a design/branding phase to establish the "look and feel" and navigation, and includes programming for a site of between 20-60+ pages.
➡ Typical Budget & Time Frame: $25,000-$100,000; 6-10 weeks

Helpful hints pop out on request while the user fills in the interview pages.

A clean interface makes filling in the profile and requesting results enjoyable.

- **Website Objective:** To help small- and medium-sized companies and departments locate, evaluate, and select the best professional service firms and vice versa.
- **Creative Strategy:** Create a clean environment and establish a progression that leads users through the system.
- **Target Audience:** Small- and medium-sized companies and smaller departments within large companies.

| 1. INTERVIEW | 2. RESULTS | 3. VENDOR PROFILE | 4. SHORTLIST | 5. CONTACT |

Search Results

Click on a vendor to view their VENDOR PROFILE, add your favorites to the SHORTLIST, and CONTACT the vendors that best match your needs.

Sort by: [Match % ▼] [SORT]

Search results are displayed clearly. Users may sort by several criteria or click on a link to find more detailed information on a vendor.

Vendor	Higher percentage equals better match
▸ Comprotex Web Design	86%
▸ Sealander & Company	86%
▸ 5 Dogs!	84%
▸ Brand New Bag Internet Solutions	84%
▸ Spiderella Web Design	82%
▸ FOXyGARCIA, Inc.	81%
▸ Barber & Anderson	81%
▸ Eagle Mountain Systems	81%
▸ Performance Concepts	81%
▸ HBC Internet Services	81%
▸ SpiritHorse Studios	80%
▸ DataWest	80%

The gray navigation bar provides access to other information and engines.

Interview

For a list of the best matched companies, describe your project needs below. Your search results will be saved for 60 days. If you've already signed up, go to the Returning Users Page. An asterisk(*) means required information.

1. What do you need legal help with? *

 ? Hint > Attorneys specialize.

☐ Establishing or running your business?

☐ Hiring or firing your employees?

☐ Hiring non-U.S. employees?

☐ Dealing with real estate?

☐ Protecting your ideas?

☐ Paying corporate taxes?

☐ Working with shareholders & securities?

☐ Collecting debts?

☐ Considering bankruptcy?

☐ Facing product liability issues?

☐ Looking for general counsel?

2. What size law firm do you want? *

 ? Hint > Bigger isn't always better.

[— Select Size — ▼]

3. How much do you want to spend? *

 ? Hint > You get what you pay for.

[— Select Rate — ▼]

4. What industry are you in?

 ? Hint > Industry knowledge is critical.

[— Select an Industry — ▼]

5. Where do you want your law firm located? *

 ? Hint > Local may be better.

Select only one of the following:

Zip Code: []

-OR-

City, State: [— Select City — ▼]

-OR-

State: [— Select State — ▼]

6. What size is your company?

 ? Hint > Critical for finding appropriate attorney.

[— Select Company Size — ▼]

The interview page carefully guides the user through the matchmaking process.

1 □	**2** □	**3** □	**4** □	**5** □	**6**	✳
PROJECT REQUIREMENTS	GENERAL INFO	CLIENTS	INDUSTRIES	CAPABILITIES	PREVIEW MY PAGE	

project requirements

To maximize bSource.com's proprietary matchmaking tool, it is important to complete steps 1 through 5. To preview how potential clients will see your company profile, select Preview My Page. You can update your company profile at any time.

To get client projects that best match your firms' abilities and intersts, accurately enter your project criteria below. (*Required Fields)

1. PROJECT TYPES *
Select one or more Project Types that your firm specializes in, or is interested in.

Communicating with key audiences
- ☐ Consumers
- ☐ Businesses
- ☐ Financial community
- ☐ Community organizations
- ☐ Government
- ☐ Investors
- ☐ Employees

Launching a business or product/service
- ☐ Publicity
- ☐ Promotions/special events
- ☐ Sales promotion
- ☐ Integrated marketing
- ☐ Internet communications
- ☐ Development/fund raising

Helping with specific communication needs
- ☐ Crisis management
- ☐ Litigation communications
- ☐ Reputation management
- ☐ Lobbying
- ☐ Trade show support
- ☐ Looking for a full service/general PR firm?

2. CLIENT BUDGET *
What clients do you want to work with, based on budget?
- ☐ Under $5K
- ☐ $5K - $10K
- ☐ $10K - $25K
- ☐ $25K - $50K
- ☐ Over $50K

3. GEOGRAPHY *
Is your firm interested in working with clients outside your city and surrounding area?

○ Yes ○ No

4. CLIENT SIZE *
What clients do you want to work with, based on Client Size? *(Check all that apply)*
- ☐ Less than $1 Million
- ☐ $1-5 Million
- ☐ $5-25 Million
- ☐ $25-$100 Million
- ☐ $100-500 Million
- ☐ Over $500 Million

NEXT

A carefully detailed vendor questionnaire allows bSource to accurately categorize a firm's abilities for potential clients.

>> Humorous promotional pieces maintain the brand image throughout the site.

We're essentially trying to help people fall in love with their business service plan.

Company Profile

Review the profile below. If you like what you see, add this vendor to your SHORTLIST. You can contact this vendor by clicking REQUEST INFO.

◀ Vendor 3 of 60 from Search Results ▶

Comprotex Web Design

http://www.comprotex.com

1805 Brazoria Drive
Mesquite, TX 75150

Sales Contact: Bob Hall

> Our goal is to make sure that we're convenient to both the buyer and the seller.

ADD TO SHORTLIST
REQUEST INFO

Company Description:
Cutting-edge designs developed for any type business, including large dynamic databases and complete site makeovers.

Size of Firm:
Boutique (less than 5 people)

Open Since:
1994

▸ Recent Clients
▸ Project Types
▸ Industry Focus
▸ Capabilities

My Notes

Record and sa
Comprotex We
notes can only
and your co-wo

Ratings:

Creative
Select ▼

Technical
Select ▼

Budget
Select ▼

Detailed Notes

SAVE MY NOTES

ADD TO SHORTLIST
REQUEST INFO

Comprotex Web Design: Recent Clients

Client	Industry	Project Type
Alicia Trevino Real Estate	Real Estate	Full Web Solution,Internet Strategy,Technical Strategy,Branding Campaign,Information & Interface Design,Animation
Custom Homes Group	Materials & Construction	Full Web Solution,Internet Strategy,Technical Strategy,Branding Campaign,Information & Interface Design
Skyline Ford	Automotive & Transport Equipment	Full Web Solution,Internet Strategy,Technical Strategy,Branding Campaign,Information & Interface Design
Summerville Ford	Automotive & Transport Equipment	Full Web Solution,Internet Strategy,Techni Strategy,Brand Campaign,Info Interface Desig
American Marazzi Tile	Materials & Construction	Full Web Soluti Strategy,Techn Strategy,Brand Campaign,Info Interface Desig
City of Mesquite	Utilities	Full Web Soluti Strategy,Techn Strategy,Brand Campaign,Info Interface Desig
Revision Skin Care	Consumer Products	Full Web Soluti Strategy,Techn Strategy,Brand Campaign,Larg Solution,Inforn Design
Childrenswear.com	Consumer Products	Full Web Soluti Strategy,Techn Strategy,Brand Campaign,Sma Catalog,Inform Design

Comprotex Web Design: Project Types

Full Web Solution	Internet Strategy
Branding Campaign	Ad Banners
Event Promotions	Small Online Catalog
Large Integrated Solution	Simple Site Design
Information & Interface Design	Animation

Comprotex Web Design: Industry Focus

ALL

Comprotex Web Design: Capabilities

Internet	Intranet
Kiosk	Streaming Audio/Video
Digitization	Personalization
Training	Concepting
Copywriting	Corporate ID
Audio Design	Java/JavaScript/VBScript
ActiveX	C/C++
CGI/Perl	SQL
HTML/DHTML	Visual Basic
NT	Unix Variant
Windows X	Oracle DB
Access DB	Dreamweaver
Flash/Shockwave/Director	Cold Fusion/ASP
Lotus Notes/Domino	Apache
Microsoft IIS	Netscape Enterprise

◀ Vendor 3 of 60 from Search Results ▶

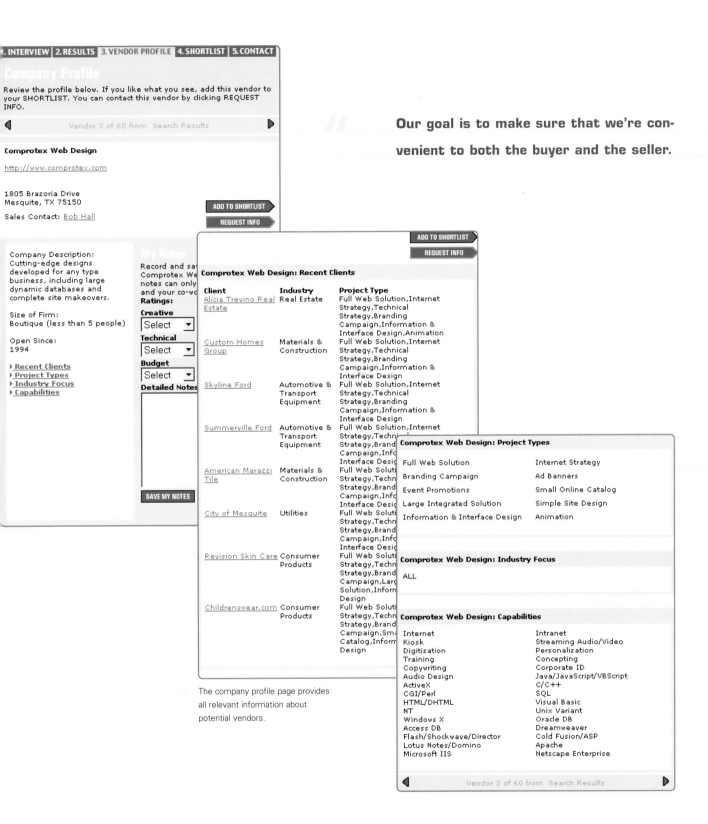

The company profile page provides all relevant information about potential vendors.

>> All Imagine Media publications use the same customer database for account inquiries.

Combining Games Content and Reader Support

- Customer service areas should be clean and straightforward.
- Use small, bright graphics to guide users through forms.
- Focus on getting the customer in and out of the support area quickly and efficiently.

28
PC Gamer/Imagine Media

Integrating Print and Online Material

The primary purpose of the PC Gamer Online site is to serve as an Internet-based update to a monthly print magazine and associated CD-ROM. (See Electronic Arts site profile for a description of gamers.) Linking the PC Gamer site to updates from another Imagine Media site, DailyRadar.com, enhances content from the hard-copy magazine. In this way, PCGamer.com appears to be dynamic without burdening the editorial staff with developing additional copy for the website.

More Than Editorial Content

A reader service environment integrated into the central site differentiates PC Gamer from other online gamer magazines. Here, customers can subscribe, renew subscriptions, and purchase gift subscriptions and back issues. Comprehensive customer service is also available, including account inquiries, billing information, and support for the CD-ROMs that are distributed with the print magazine each month. Enabling users to access support 24 hours a day, 7 days a week, creates an advantage to both users and Imagine Media.

The most attractive feature of the reader service area is the user-friendly utility. The standard bells and whistles of game-related sites are stripped away, leaving a clean white interface and bright colors to guide users through the various forms and services. To consolidate the customer service aspect of the magazines under the Imagine Media umbrella, PC Gamer customers are directed to a central Imagine Media customer service center customized with PC Gamer art and relevant content. Standard black text on a white background punctuated by a few clear images helps users find the answers they need as quickly as possible. The same design approach applies to the subscriptions area: Users enter information into easy-to-understand forms enhanced by a few bright-red graphics delineating the steps in the purchase process.

> **A reader service environment integrated into the central site differentiates PC Gamer from other online gamer magazines.**

PC Gamer/Imagine Media: 150 North Hill Drive, Brisbane, CA 94005, (415) 468-4684

Executives: PC Gamer editorial staff **Design Team:** Internal **Toolbox:** HTML, JavaScript

16　17　18　19　20　21　22　23　24　25　26　27　28　29　30

>> The PC Gamer home page features articles from the print magazine as well as links to timely news from DailyRadar.com.

>> All customer service functions are addressed in the reader service center.

Standard black text on a white background punctuated by a few clear images helps users find the answers they need as quickly as possible.

- **Website Objective:** Create an online presence that enhances the content of the print magazine and accompanying CD-ROM. Develop a user-friendly support and customer service area as a part of this presence.
- **Creative Strategy:** Translate the print magazine format to the web.
- **Target Audience:** Game software fans, mostly male, ages 14–45.

FAQs and online technical support for CD-ROMs allow users to receive answers 24 hours a day.

>> The reader service navigation bar details the online services available to customers.

>> Simple subscription forms speed the customer through the purchase process.

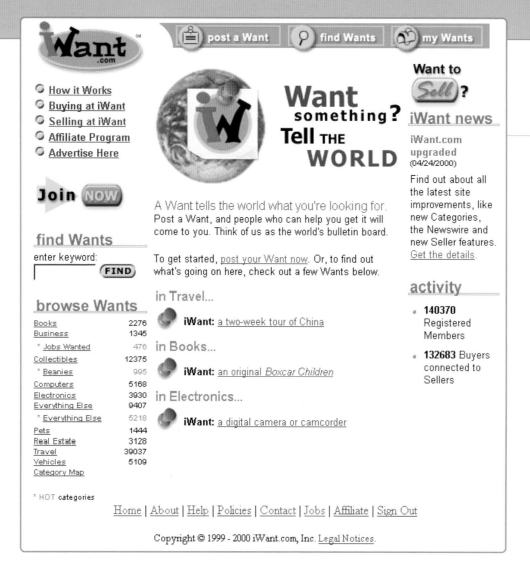

Helping Sellers and Buyers Find
Each Other on the Internet

- Make sure users get accurate results through the search engine.
- Use a familiar design metaphor for the site.
- Keep users focused on the product.

iWant.com

The Bulletin Board Concept

Community bulletin boards have been around at least since the invention of cork and stickpins. iWant.com transfers the bulletin board concept to the Internet, better organizes it, and puts the buyers in the driver's seat; instead of having sellers hawk their wares, buyers register for what they want and need. This exchange of roles enhances the sales process in three ways. First, instead of sifting through hundreds of advertisements that don't quite match their requirements, buyers state exactly what they want. Second, sellers can use iWant.com's efficient search engine to find buyers who are already interested in what's being sold. Third, in addition to bringing qualified buyers to sellers, iWant.com helps sellers put their best foot forward with a list of hints and a range of technological services.

E-business web pages and cards help sellers clarify their message as well as enhance their trustworthiness in the eyes of buyers. An automated search feature enables sellers to schedule a search on either a daily or weekly basis. The results are automatically forwarded to the seller's mailbox for follow-up—a feature especially helpful to small businesspeople who want to spend their time selling rather than searching.

The Look

Because the bulletin board concept is so familiar and friendly, iWant designers kept the concept for the theme of the site. Each posted "want" is framed on pink paper, complete with curled edges and a stickpin through the iWant logo at the top. Vivid and clear graphics throughout the site guide users through the search and registration processes. Generous use of white space makes it easy to focus on the results of a search and encourages speedy navigation.

iWant.com helps sellers put their best foot forward.

iWant.com: 24 New England Executive Park, 2nd Floor, Burlington, MA 01803-5000, (781) 229-9554

Executives: Shabbir Dahod, President and CEO, Mark Belinsky, Vice President of Online/Partner Marketing, Rob Gurwitz, Vice President of Internet Service
Design Team: Peter Spellman, Chief Technology Officer **Toolbox:** HTML, JavaScript

- **Website Objective:** To build an online service that connects sellers to a community of qualified buyers and initiates one-to-one dialogues.
- **Creative Strategy:** To create a bulletin board environment that enables buyers and sellers to find each other quickly and easily.
- **Target Audience:** Anyone who wants to buy or sell something.

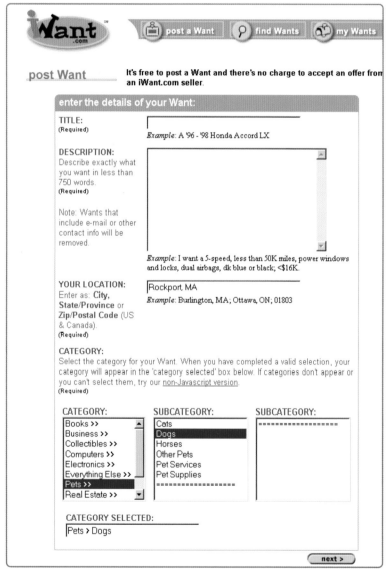

>> The iWant.com registration forms are simple and easy to follow.

>> Intuitive graphics and vivid colors illustrate the iWant.com concept.

>> Simple, bright, and clean, the buyers' navigation bar leads users through the site.

Each posted "want" is framed on pink paper, complete with curled edges and a stickpin through the iWant logo at the top.

> "Instead of reviewing sellers hawking their wares, buyers register for what they want and need."

iWant: '97-00 Family Station wagon

Description: A family station wagon with low miles and good maintenance record. Third seat would be ideal.

Posted By: 15munson

Where: Rockport, MA

Post Date: 05/15/2000

Replies: 0

>> A posted "want" appears on the screen as a note attached to a bulletin board.

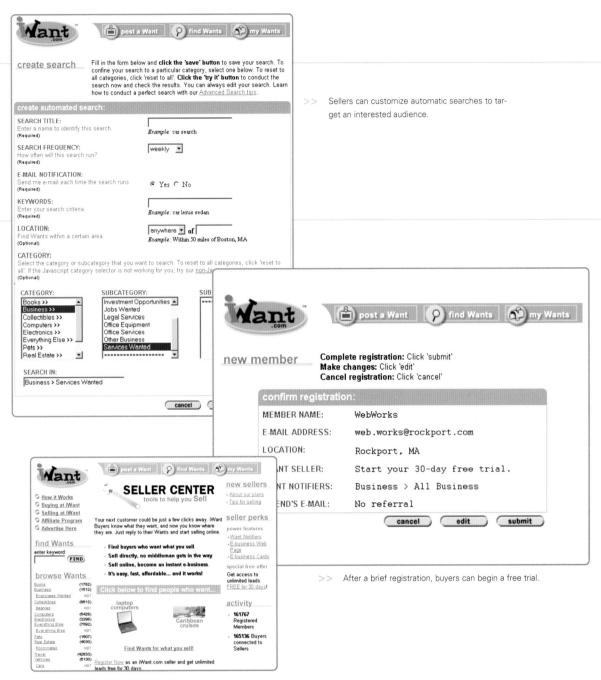

>> Sellers can customize automatic searches to target an interested audience.

>> After a brief registration, buyers can begin a free trial.

>> A Seller Center helps sellers effectively market their merchandise.

>> The home page details important marketing points and invites users to enter the site.

Generating Interest for an Offline Event

- Present as much information at one time as possible.
- Use color instead of text to make distinctions.
- Make sure the technology doesn't overshadow the product.

30
ab2000

What Happened

Sometimes the Internet can be utilized to support an offline event that didn't go exactly as planned. That was the genesis of the ab2000 site. When a trade fair didn't get off the ground, the organizers of ab2000 decided that the best course of action would be to create a virtual fair as a means of generating interest from potential participants and creating a buzz about the event.

Developing an interactive environment to mimic a real-world setting often helps people visualize more accurately what the live event will be like. The ab2000 site allows visitors to see what other vendors are involved in the fair, scope out the products that will be promoted, view the layout of the convention floor, and register online.

3-D World in a 2-D Format

Netdesign.nl, a Dutch design firm based in Amsterdam, decided that three-dimensional modeling took the virtual fair concept too far. Instead, they devised an environment where vendor information, online registration, and event news and information are all presented on one screen, without overpowering the user with content.

The careful use of bright color to distinguish points of information and innovative use of a masked scrollbar in the information frame enable the potential vendor to quickly access details about the fair or other vendors while maintaining access to the online registration form.

"We're always interested in utilizing technology in different ways," says Earl de Wijs, lead designer for the ab2000 site at netdesign.nl. "Creating an online environment to successfully generate interest in an offline event allowed us to stretch our creative imaginations in ways we hadn't tried before. With the ab2000 website, the fair's organizers can point potential participants to the URL and demonstrate the advantages of being a part of the fair in ways they weren't able to before."

ab2000: L. Simon, Postbus 34, 2501 AG Den Haag, The Netherlands, 31-20-4220850

Executives: Mevr. L. Simon, Director **Design Team:** Netdesign.nl **Toolbox:** Allaire Homesite, Bradsoft Topstyle, Adobe Photoshop and ImageReady

Standhouders 1 9

contact | producten | 1 | 2 | 3 | 4 | 5 | vraag en antwoord

De interactie met bezoekers op uw stand:

Er zijn vier contactmogelijkheden:

· Een info-aanvraagkaartje. De bezoeker hoeft slechts op de
verzendknop te klikken en u ontvangt de aanvraag direct via E-r
· Een hyperlink naar uw eigen website.
· Via E-mail. Door op uw E
· Vragen/antwoordenpagina
opgenomen. Bezoekers ku
vraag krijgt u direct via E-r
ongenomen on de interacti

>> General information on the trade
show is available to potential ven-
dors in one frame window.

Informatie aanvraag Fictief BV. ?

naam: [] functie: []

bedrijf: [] e-mail: []

telefoon: [] adres: []

postcode: [] plaats: []

verzend

>> A registration and information request form is available
on all screens.

**Developing an interactive environment to mimic a real-world setting often helps
people visualize more accurately what the live event will be like.**

- **Website Objective:** To develop an online tool to support sales and promotion of a trade fair.
- **Creative Strategy:** Convey a three-dimensional event in a two-dimensional environment.
- **Target Audience:** Technical personnel, managers, and engineers from the field of industrial driving techniques (electrical and hydraulic drives, electronics, gears).

>> Regularly updated news and information is featured in its own frame.

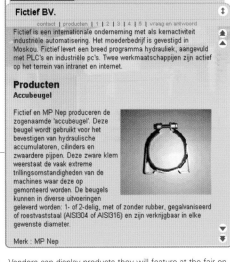

>> Vendors can display products they will feature at the fair on the website.

>> Careful use of color and frames helps distinguish points of information.

Directory

ab2000
Postbus 34
2501 AG Den Haag
The Netherlands
31 (0)20 4220850
www.ab2000.nl

nv Bank Nederlandse Gemeenten
P.O. Box 30305
2500 GH The Hague
The Netherlands
31 (0)20 4220850
www.bng.com

bluefly.com
42 W. 39th Street, 9th Floor
New York, NY 10018
212-944-8000
www.bluefly.com

bSource.com
415 Bryant Street
San Francisco, CA 94107
415-644-9800
www.bSource.com

chipshot.com
1452 Kifer Road
Sunnyvale, CA 94086
408-746-0600
www.chipshot.com

Citibank Hong Kong
Central One Exchange Square,
Unit 1501
15/F, Hong Kong
852 2526 5668
www.citibank.com.hk

Datek Online
100 Wood Avenue South
Iselin, NJ 08830-2716
732-516-8340
www.datek.com

Dell
One Dell Way, Box 8109
Round Rock, TX 78682
800-WWWDELL
www.dell.com

drugstore.com, Inc.
3150 139th Ave SE
Suite 100
Bellevue, WA 98005
425-372-3200
www.drugstore.com

EBSCO Publishing
10 Estes Street
Ipswich, MA 01938
978-356-6500
www.ebsco.com/research

EdFinder.com
337 Summer Street
Boston, MA 02210
800-252-7910
www.EdFinder.com

Electronic Arts
1450 Fashion Island Blvd
San Mateo, CA 94404
650-571-7171
www.ea.com

Forrester Research
400 Technology Square
Cambridge, MA 02139
617-497-7090
www.forrester.com

Hallmark Cards
2501 McGee
MD 100
Kansas City, MO 64108
800-Hallmark
www.hallmarkflowers.com

Harrods Online
Harrods
Brompton Road
London
SW1X 7XL
0171-730 1234
www.harrods.com

ImageCafé Inc.
5565 Sterrett Place
Suite 210
Columbia, MD 21044
410-997-3830
www.ImageCafe.com

iWant.com
24 New England Executive Park
2nd Floor
Burlington, MA 01803-5000
781-229-9554
www.iWant.com

Marvel Comics
387 Park Avenue South
New York, NY 10016
212-696-0808
www.marvel.com

The Motley Fool
123 North Pitt Street
Alexandria, VA 22314
703-838-3665
www.fool.com

MuZicDepot
525 S. Flagler Drive, Suite 400
West Palm Beach, FL 33401
561-832-0026
www.MuZicDepot.com

NextCard, Inc.
595 Market Street, Suite 1800
San Francisco, CA 94105
415-836-9700
www.nextcard.com

Nordstrom, Inc.
1617 Sixth Avenue
Seattle, WA 98101-1742
888-282-6060
www.nordstrom.com

Payless Shoe Source
P.O. Box 1189
Topeka, KS 66601-1189
785-295-6695
www.payless.com

PayPal
X.com
P.O. Box 50185
Palo Alto, CA 94303
877-6-PayPal
www.PayPal.com

PC Gamer/Imagine Media
150 North Hill Drive
Brisbane, CA 94005
415-468-4684
www.pcgamer.com

Philips Lighting Trade Link
200 Franklin Square Drive
P.O. Box 6800
Somerset, NJ 08875-0050
800-555-0050
www.tradelink.philips.com

StarMedia Shopping and
Auctions Channels
29 West 36th Street, 5th Floor
New York, NY 10018
212-548-9600
www.StarMedia.net/shopping
www.StarMedia.net/subastas

The Wall Street Journal
Interactive Edition
Dow Jones & Company
200 Liberty Street
New York, NY 10281
212-416-2900
www.wsj.com

wine.com
650 Airpark Road
Suite D
Napa, CA 94558
707-265-2860
www.wine.com

WingspanBank.com
201 North Walnut Street
Wilmington, DE 19801
302-282-7313
www.WingspanBank.com

About the Author

Katherine Tasheff Carlton is a freelance writer, consultant, and media content manager. Since 1995 she has worked with a wide variety of clients in the entertainment, finance, and technology industries. She was the director of internet services for TradeMedia.net, a division of Phillips Electronics, N.V. In this position, she managed the launch of more than fifteen web sites and supervised the long-term development of electronic commerce projects, both on CD-ROM and the internet. She lives in Rockport, Massachusetts.